P.O. Box 503
Wilson, WY
83014

ANDREA KLING
JULY 87

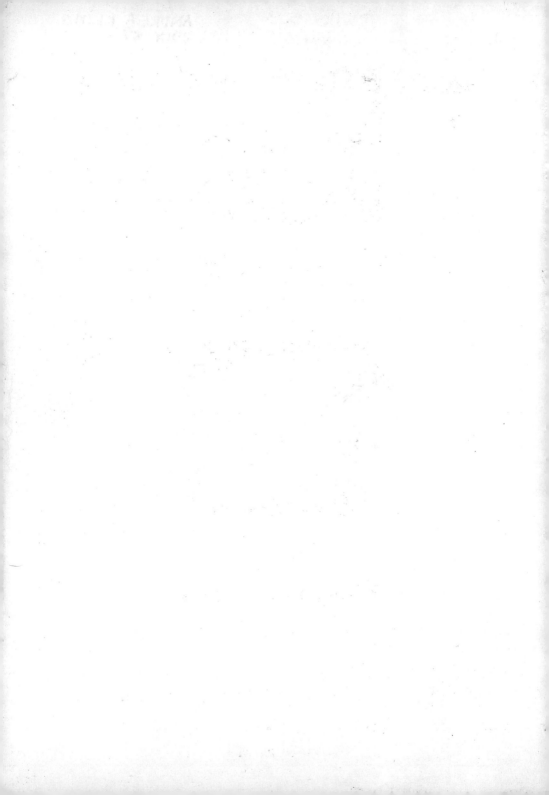

COLOR HARMONY

A Guide to Creative Color Combinations

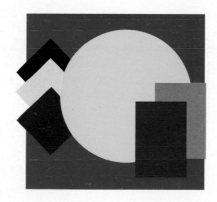

Hideaki Chijiiwa

Professor, Musashino College of Art

Rockport Publishers · Rockport, Massachusetts

Distributed by North Light Books
Cincinnati, Ohio

Printed in Japan

First published in the United States in 1987 by:
Rockport Publishers
5 Smith Street
Rockport, Massachusetts 01966
(617) 546-9590

For distribution by
North Light, an imprint of Writer's Digest Books
9933 Alliance Road
Cincinnati, Ohio 45242

First U.K. edition 1987
Published by

Rockport Publishers Inc. for
Greenwood Publishing
The Tallet, Church Street
Minehead, Somerset
England TA24 5JX
(0643) 5511

First Canadian edition 1987
Published by

Rockport Publishers Inc. for
Koko Company
37 Francine Drive
Willowdale M2H 2G5
Ontario, Canada

Edited and designed by Geoffrey Mandel
Translated by Keiko Nakamura
Color consultant: Lucy Lovrien

First published in Japan as *Color Harmony Guide* by Nagaoka Shoten, Inc.

English edition arranged with Nagaoka Shoten Inc. through Japan Foreign-Rights Center

Library of Congress Cataloging-in-Publication Data
Chijiiwa, Hideaki, 1938–
 Color harmony.

 Translation of:
 1. Color guides. 2. Color in art. I. Title.
ND1489.C45 1986 701'.8 82-22106
ISBN 0-935603-06-9

DIC numbers in this book depend on *DIC Color Guide,* Tenth Edition.

Contents

The bold, contrasting blue and red sails give us a sense of the excitement of this yacht race (*see page 26*).

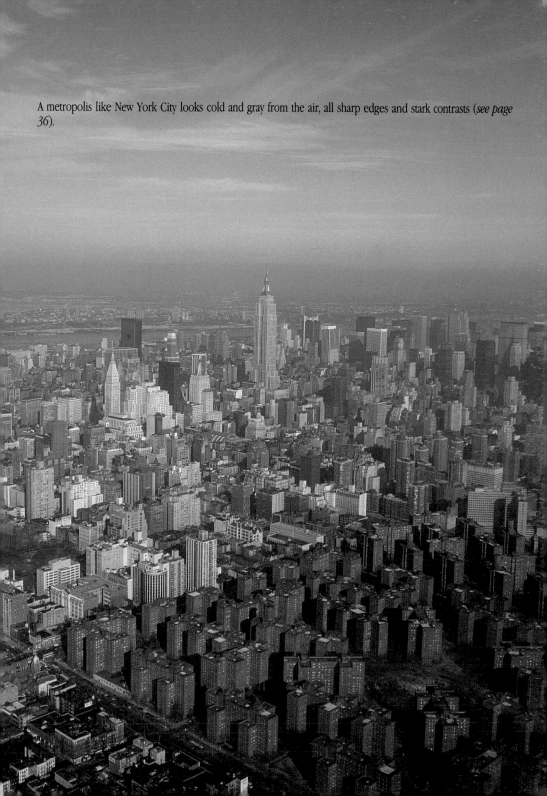

A metropolis like New York City looks cold and gray from the air, all sharp edges and stark contrasts (*see page 36*).

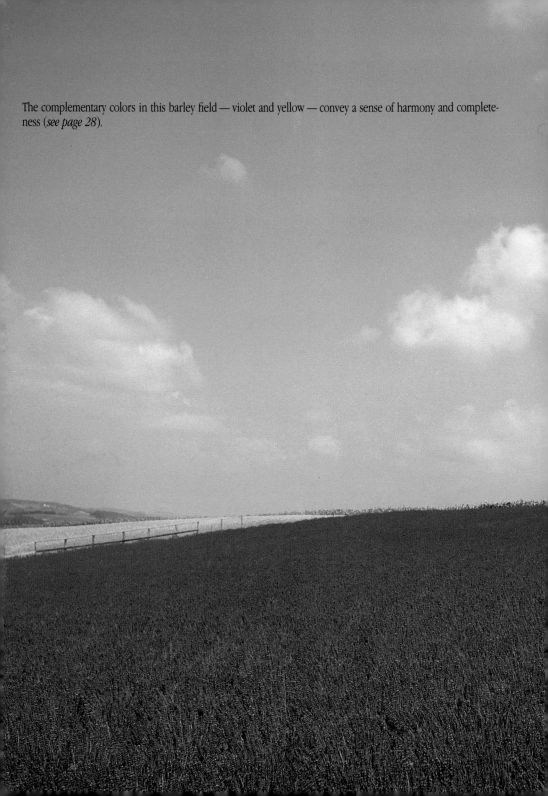

The complementary colors in this barley field — violet and yellow — convey a sense of harmony and completeness (*see page 28*).

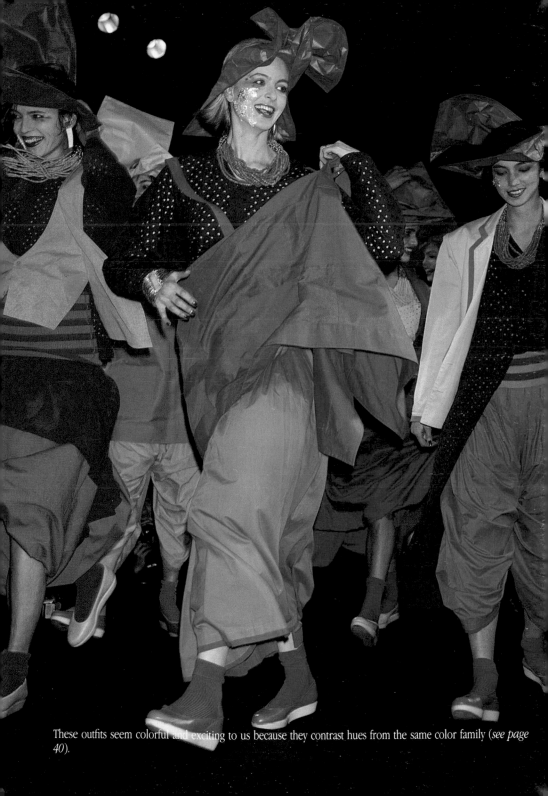

These outfits seem colorful and exciting to us because they contrast hues from the same color family (*see page 40*).

How to Use This Book

Choosing colors is fun, but there's more to choosing an effective color scheme than simply picking the colors that appeal to you, just as there's more to being a connoisseur of fine art than "knowing what you like." The colors that you like best might not go well together (the best example of this is Howard Johnson's favorite color combination — turquoise and orange), or they might not convey the effect that you're after. Color harmony is as much of a science as an art, and follows very specific rules about hue, brightness, and contrast — rules that we'll discuss in detail beginning on *page 44*.

In color as well as music, *harmony* means an aesthetic arrangement of parts to form a pleasing whole: a musical composition, a painting, or a graphic design. All music from Mozart to Madonna consists of the same twelve notes, and all graphic designs from Gutenberg to Glaser use the same palette of colors. If the *science* of color harmony is knowing which colors to use, the *art* is knowing what order to put the colors in, and what proportions of each. In this book, we've tried to mix the scientific and the aesthetic approaches: some of the color combinations examine all the possible variations on a single theme (for instance, *complementary hues* beginning on *page 78*), while others were chosen simply for their beauty and pleasant associations (such as the *natural colors* beginning on *page 102*).

In order to use this book most effectively, we suggest that you read it through from start to finish, instead of just browsing. Each section is designed to help you along the path to choosing a specific combination of two or more colors: a color scheme that you can use when you plan your next painting, ad layout, book design, or even your wardrobe. Start with a general sense of the effect that you're after: do you want colors that are warm or cool? striking or quiet? surprising or subtle? Beginning on *page 46*, you'll find hundreds of color combinations to suit any mood or purpose.

Finally, it's important to remember that the color combinations illustrated in this book show colors on a very small scale. When you magnify them a hundred times on your posters or layouts, you'll find that a seemingly innocuous color suddenly looks much bolder. (Think of apple green, a lovely color in small doses, splashed over the walls of your apartment.) In general, the larger the area, the bolder the color appears, so it's often better to choose color schemes with relatively weak tints and low contrast.

Here's how the material in this book is organized:

Pages

All the color schemes and combinations in this book use 61 basic colors, which are illustrated in the table below. Each color is identified here and throughout the book by the Color number of *DIC Color Guide*, published by Dainippon Ink & Chemicals, Inc.

The 44 basic colors on the top four rows of the color table are actually shades of 11 basic hues: the ten colors in the color wheel (*see page 10*) plus orange-yellow.

● **Light colors** (*row 1*) are mixtures of the 11 basic hues with white, which lessens the intensity of the colors.

● **Dull colors** (*row 2*) are mixtures of the 11 basic hues with gray, which tends to muddy the colors.

● **Vivid colors** (*row 3*) are the 11 basic hues.

The Basic Colors

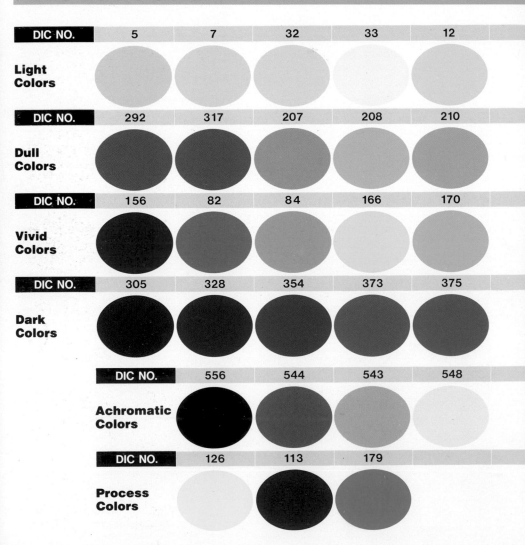

DIC NO.	5	7	32	33	12
Light Colors					
DIC NO.	292	317	207	208	210
Dull Colors					
DIC NO.	156	82	84	166	170
Vivid Colors					
DIC NO.	305	328	354	373	375
Dark Colors					
DIC NO.		556	544	543	548
Achromatic Colors					
DIC NO.		126	113	179	
Process Colors					

● **Dark colors** (*row 4*) are mixtures of the 11 basic hues with black.

In addition, 17 colors have been added to round out the 44 basic colors:

● **Achromatic colors** (*row 5, left*) are literally "colors without color" — in other words, black and shades of gray.

● **Process colors** (*row 6, left*) are yellow, magenta, and cyan, which are used (along with black) in the four-color printing process. Any of the 61 basic colors can be simulated with the four process colors (*see page 142*).

● **Pink and blue** (*rows 5 and 6, right*) are extremely popular among graphic designers, so we've included some additional hues and shades.

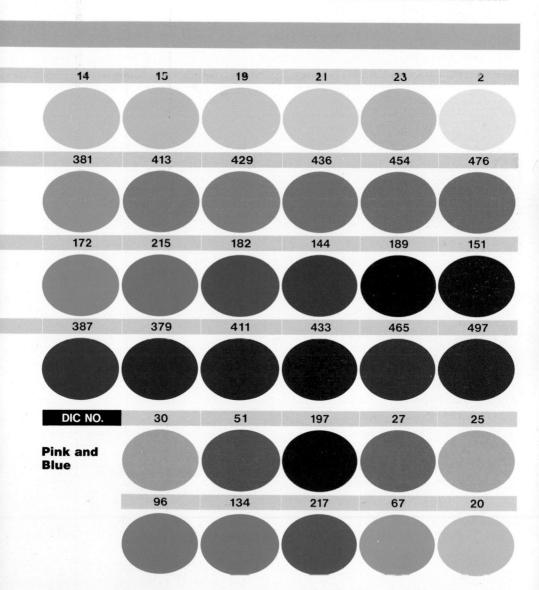

The Color Wheel

Every color in the spectrum has three different characteristics:

● **Hue** is the actual color. In the color wheel (*below*), the ten hues (moving clockwise from 12 o'clock) are red (*DIC 156*), orange (*DIC 82*), yellow (*DIC 166*), yellow-green (*DIC 170*), green (*DIC 172*), blue-green (*DIC 215*), blue (*DIC 182*), blue-violet (*DIC 144*), violet (*DIC 189*), and red-violet (*DIC 151*). These colors correspond to the *vivid colors* on the third row of the basic color table on *pages 8-9*; on the table, an eleventh color, yellow-orange (*DIC 84*), has been added between orange and yellow.

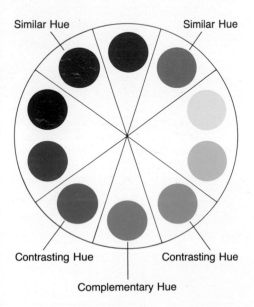

Similar Hue Similar Hue

Contrasting Hue Contrasting Hue

Complementary Hue

● **Lightness** is the *shade* of the color: the amount of white or black mixed with the hue. For instance, in the basic color table, pink and crimson are shades of red (*DIC 156*): pink (*DIC 5*) is red mixed with white, and crimson (*DIC 305*) is red mixed with black.

● **Saturation** is the *vividness* or *intensity* of the color. Red (*DIC 156*) is more saturated than russet (*DIC 292*), even though they both use the same hue and shade.

The relationship between the hues on the color wheel is fixed, regardless of the lightness or saturation of the colors. For instance, you could easily substitute the *light colors, dull colors,* or *dark colors* on the basic color chart for the *vivid colors* illustrated on the color wheel, and the relationship between the hues would be the same.

● **Similar colors** are adjacent, like red and orange.

● **Contrasting colors** have three colors between them on the color wheel, like red and green, or red and blue.

● **Complementary colors** are on opposite sides of the color wheel, like red and blue-green.

We'll discuss these relationships in more detail beginning on *page 46*.

12-19 The Living Palette

There are an infinite number of colors, but all of them are combinations of the three primary colors — red, yellow, and blue — plus varying degrees of black and white. Along with green, purple, and brown, these colors make up the vast majority of the hues that we see in daily life: in books and magazines, on packaging and household appliances, and on the clothes we wear. On these pages, we'll look at some of the uses and emotions associated with these eight familiar colors — a useful starting point for any color scheme.

20-25 The Color Guide

The next step in choosing a color scheme is to use the three characteristics of color described on *page 10* — hue, lightness, and saturation — to divide colors into six broad categories:

● *Warm* and *cool* refer to the hue, the actual color.

● *Light* and *dark* refer to the shade, the amount of white or black mixed with the color.

● *Vivid* and *dull* refer to the vividness or intensity of the color.

26-43 Color Schemes

A *color scheme* is an overall mood for your painting, illustration, or graphic design, and some moods are easier to achieve than others. It seems logical that a *natural* mood can be conveyed with earth tones like brown and green, and a *warm* mood with warm colors like red, orange, and yellow, but how do you create a color scheme that's *striking, tranquil, exciting, young, feminine,* or *surprising*? The photographs and the color combinations on these pages — selected from among the hundreds of color combinations on *pages 44-119* — will show you.

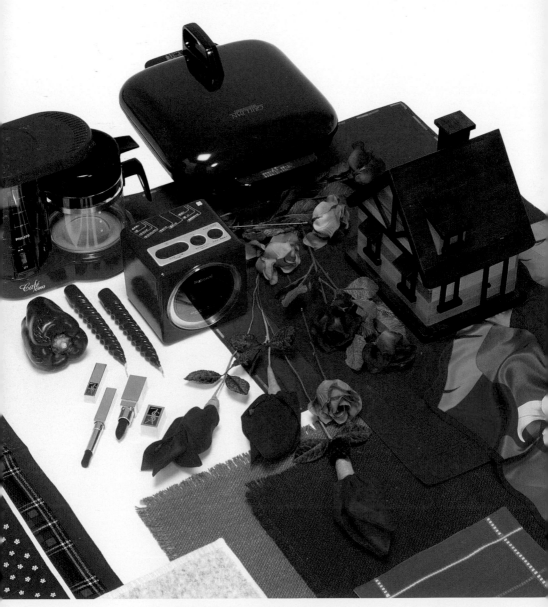

Red

Red is passionate, the color of hearts and flames: it attracts our attention, and actually speeds up the body's metabolism. Red is popular among the young, and pink in particular is associated with romance. Deep red, on the other hand, looks aristocratic.

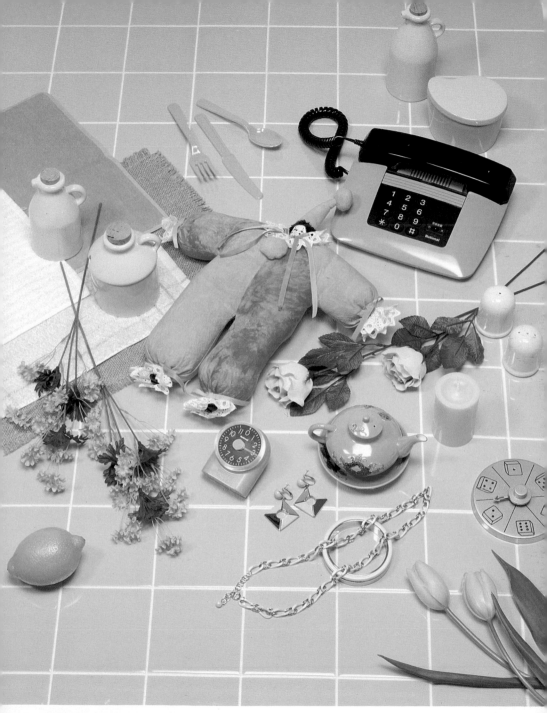

Yellow

Yellow is lively and happy, the color of sunshine and daffodils. Because it is so relentlessly cheerful, we tend to tire of it quickly; an apartment painted in bright yellow would be oppressive, but pale yellow would make it breezy and springlike.

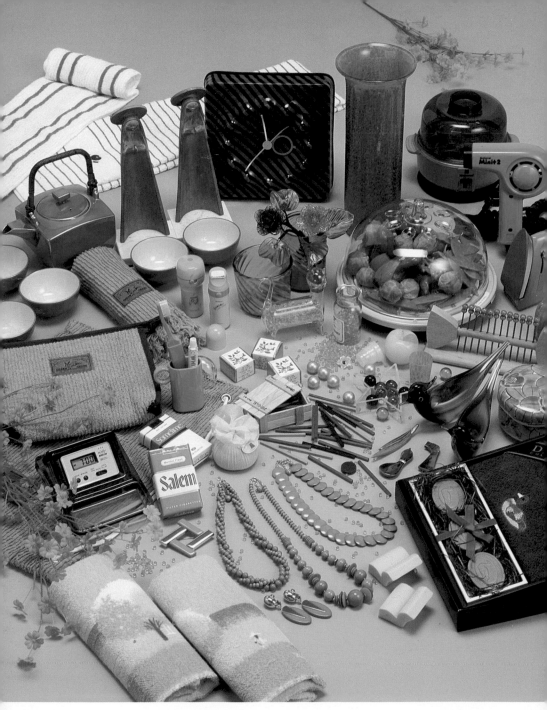

Green

Green is tranquil and pastoral, the color of trees and grass. Bright green reminds us of spring and fertility, but it's also the color of mildew, poison, and jealousy. Dark green is an eloquent color, and brings to mind the deep quiet of a pine forest.

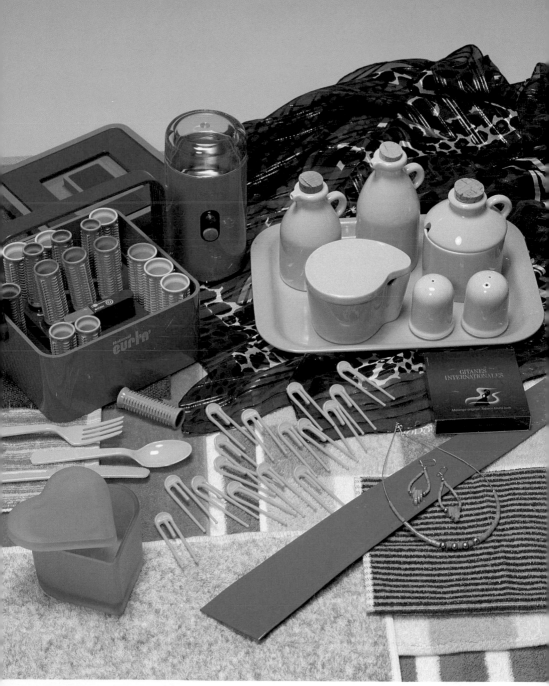

Blue

Blue is the color of the sky and the sea. Like green, it has a calming effect, but it's also quite powerful — the strongest of the familiar colors after red. Light blue looks young and sporty, but royal or navy blue has a dignified, wealthy air.

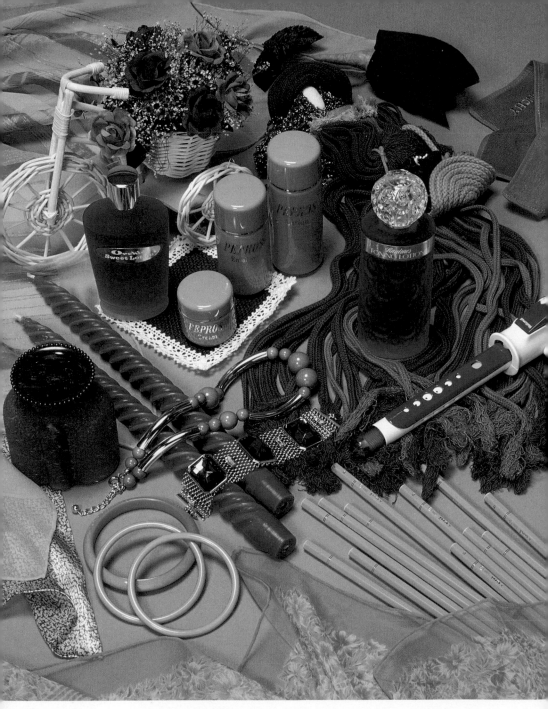

Purple

Purple is a sophisticated color, long associated with royalty. We don't often see it in nature, so we think of it as an "artificial" color, and find it a bit hard to take. The lighter shades of purple have dominated women's fashions in recent years.

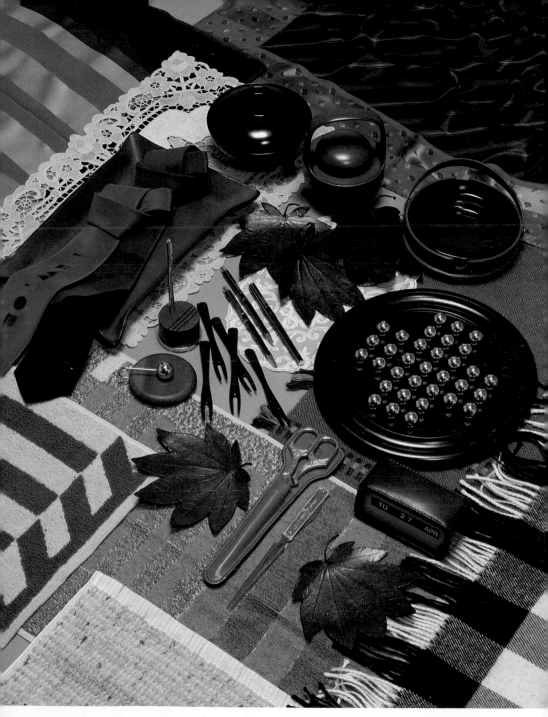

Brown

Brown is rich and fertile, like soil; and it's also sad and wistful, like the leaves in autumn or an October moon. Light brown, tan, and beige give fabrics and housewares a rustic, natural look, while dark brown suggests opulent hardwoods and leather.

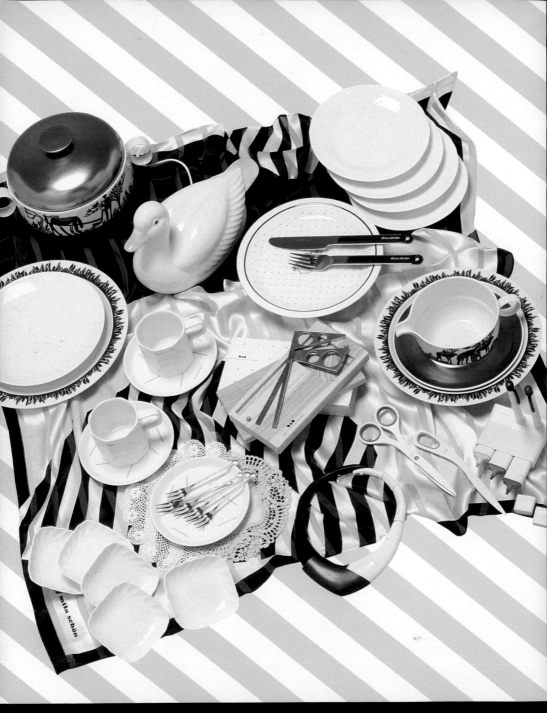

White

White is the color of purity, virginity, innocence, and peace, but it's also associated with hospitals, sterility, and winter. This dichotomy is also seen in white household objects: they either look expensive (like bone china) or disposable (like paper plates).

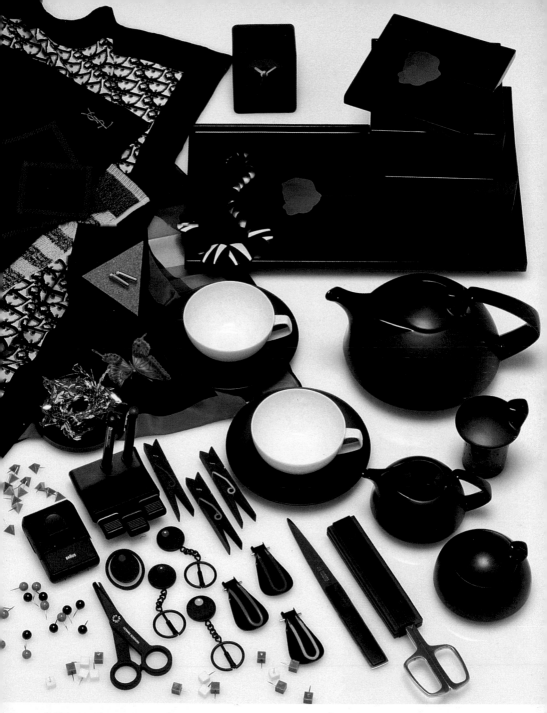

Black

Black is the color of night and death, and is often linked with evil ("black magic"). Its unorthodox appearance has made it popular with artists, but it's also associated with wealth and elegance (black household items tend to look expensive).

Warm Colors

The hues from red to yellow, including orange, pink, brown, and burgundy, are called the warm colors. In fact, the wavelength of red light is very close to that of infrared radiation, which transmits heat. Warm colors are bright, splashy, and aggressive, like the molten lava flowing from this crater. More than any other colors, they attract the eye and excite our emotions. In the workplace, warm colors can heighten motivation and make us work faster, and on books, magazines, and posters, they almost always grab our attention. Warm colors make a color scheme look brash, cheerful, and exuberant.

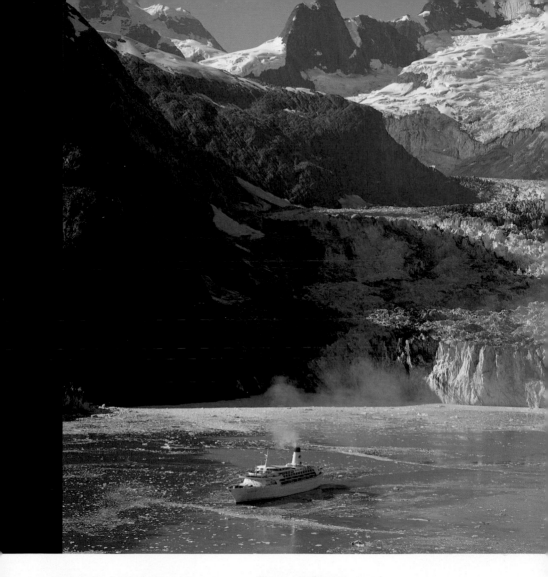

Cool Colors

The hues from green to violet, including blue and all the shades of gray, are known as cool colors — perhaps because they remind us of snow and ice, as in this photograph of a summer cruise to Alaska. Cool colors have exactly the opposite effect as warm colors: they slow down the body's metabolism, and are even used in hospitals to calm manic patients. At times, they can seem unbearably gloomy and oppressive, like the paintings of Picasso's Blue Period. However, cool colors can sometimes make a nice change: cool shades of blue and green look clean and inviting, like a bracing dip in an icy mountain lake.

21

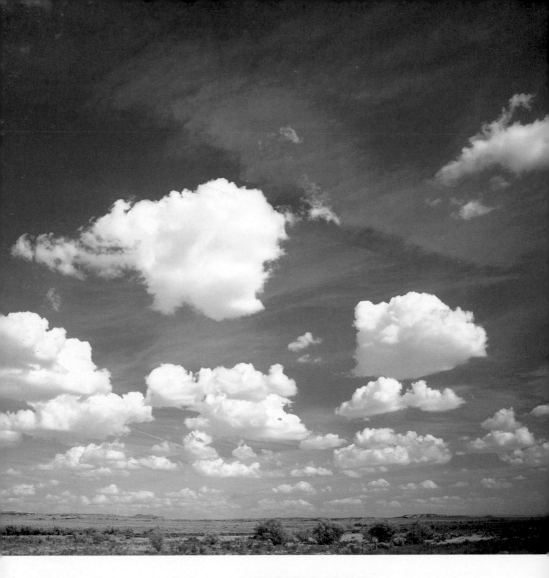

Light Colors

Light shades of any color look soft and ethereal, like cotton candy or fleecy clouds floating in the summer sky. The hue is relatively unimportant: even light shades of orange and purple have a gossamer, fairy-tale quality. Light colors are overwhelmingly preferred in interior design (dark colors tend to make a room look gloomy), and are popular in women's fashions as well, but lack the eye-grabbing quality that most graphic designers seek. Nevertheless, a color scheme that uses only light colors can be effective in its own quiet way, and may actually stand out from the brash, overconfident color schemes that surround it.

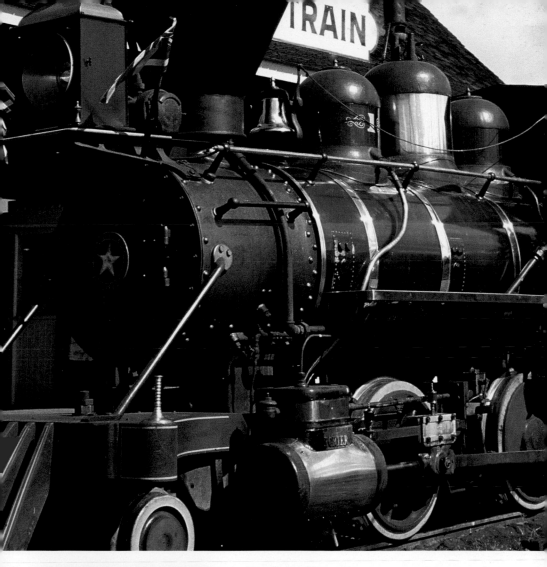

Dark Colors

Black and other dark shades feel heavy, like rain clouds dense with moisture. Black, in particular, seems as strong and as solid as the cast-iron boiler of this old-fashioned locomotive. Dark red, dark purple, dark green, and dark blue are the colors most often associated with royalty, and have an aura of almost ponderous dignity. Dark colors are also the colors found in men's suits and formal wear, and give furniture and household furnishings an expensive, hand-crafted look. The dark colors are used mostly for type and accent in graphic design, and are usually paired with lighter, more conventional colors.

Vivid Colors

As we can see by looking at *pages 8-9*, all the vivid colors have powerful personalities. Red stands out (looking at all the red in this photograph is like listening to headphones at full volume), but blue and yellow are also vivid, and paradoxically, so are black and white. However, when you combine two or more vivid colors, the result is cacophony — too many voices shouting at once. For some uses, this is fine: bright, contrasting colors are often used in fast-food restaurants and in children's toys and clothing. But perhaps because the eye tires of them so quickly, vivid color schemes tend to look a little tacky.

Dull Colors

When gray is added to a color, the personality of the color is softened: if you add enough gray, the result is a muddy shade like the dull colors on *pages 8-9*. Our eye instinctively prefers bright, vivid colors; dull colors are annoyingly vague and diffuse, and create a blurry impression (in this photograph of Mt. Fuji, the eye wants to cut through the mist and clouds and pick out some details of the mountain). However, dull colors help to reduce tension, and can give color schemes a meditative, dream-like mood. Dull colors run the risk of looking insipid, so use at least one vivid color as an accent in your color scheme.

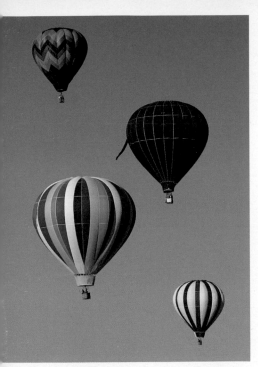

Striking

Some colors are so striking, they almost jump off the page at us. Bright red is the best example of this, but the other warm colors, orange and yellow, also catch our eye when we see them on a road sign or at a construction site. The cool colors like green and blue have a much lower profile, and purple and brown are all but invisible when placed next to red.

The easiest way to put together a striking color scheme is to use red as one of your colors. Red isn't easily confused with other hues: it makes things seem much larger and closer than they really are, and brings us to a screeching halt when we see it in a traffic light or a stop sign. In addition, a striking color scheme should contrast light colors with dark colors, like the colorful stripes on the balloon in this photograph.

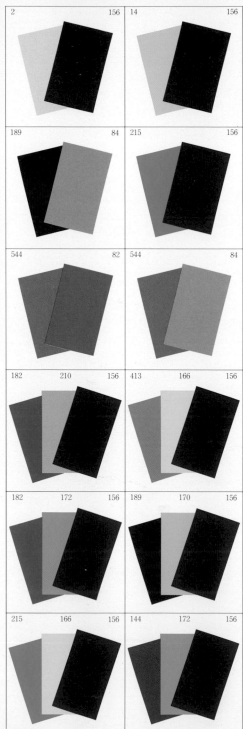

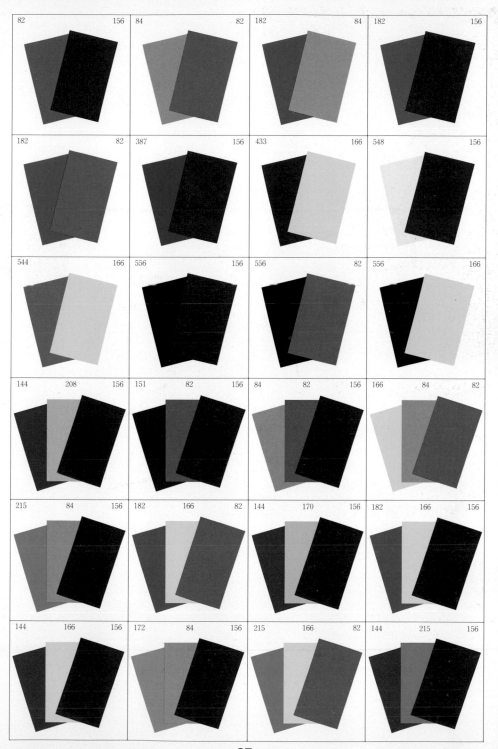

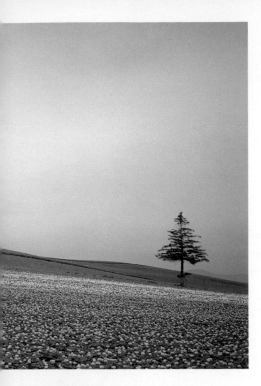

Tranquil

The guidelines for a tranquil color scheme are exactly the opposite as for a striking scheme: use cool colors like blue and green, and avoid strong contrasts. Secondary colors like green, turquoise, and purple are more tranquil than primary colors, and light shades like pink and pale blue are more tranquil than vivid shades (compare the pale, peaceful sky in the photograph above to the bold, blue sky on *page 26*). Black and white are striking, but gray is tranquil.

While striking color schemes seem to go best with images that are urban, masculine, and modern, a tranquil color scheme works best in a natural setting: with curves instead of straight lines, and over large areas like the sky and fields in this photograph. A tranquil color scheme should convey a sense of quiet familiarity; it may seem old-fashioned to some eyes, but like a Monet painting, we never grow tired of looking at it.

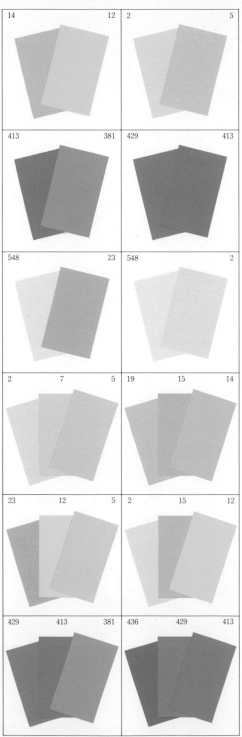

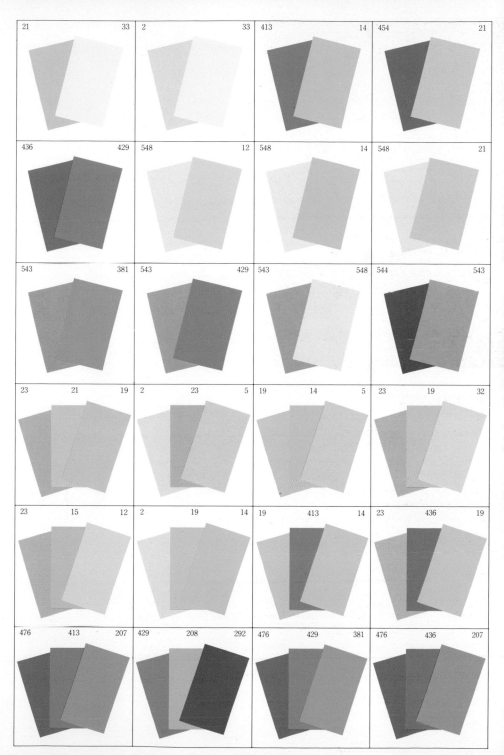

29

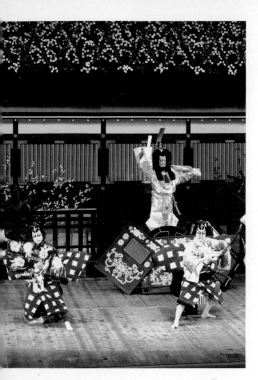

Exciting

Like a striking color scheme, an exciting color scheme makes use of bright red and strong contrasts; but instead of contrasting red with the other primary colors, yellow and blue, an exciting color scheme uses unusual secondary colors like yellow-orange, pale green, purple, and magenta. A good example would be the costumes in traditional Japanese *kabuki* theater, which contrast these bright colors with the dark green, brown, or grey of the curtain.

In general, warm colors are more exiting than cool colors, and secondary colors are more exciting than primary colors, perhaps because our eyes are so used to seeing primary colors. Exciting colors tend to clash with each other (notice the red and purple costume in the photograph), and this can actually heighten the sense of motion and excitement. To make it easier on the eyes, use a dark color like grey or black to "mediate" between the clashing hues.

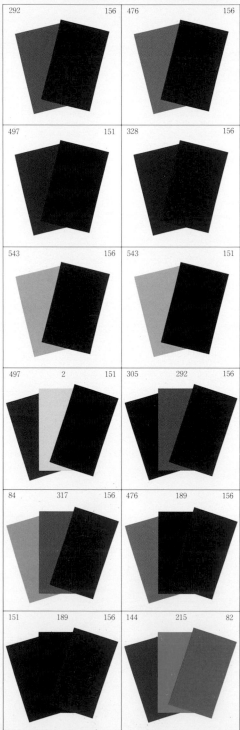

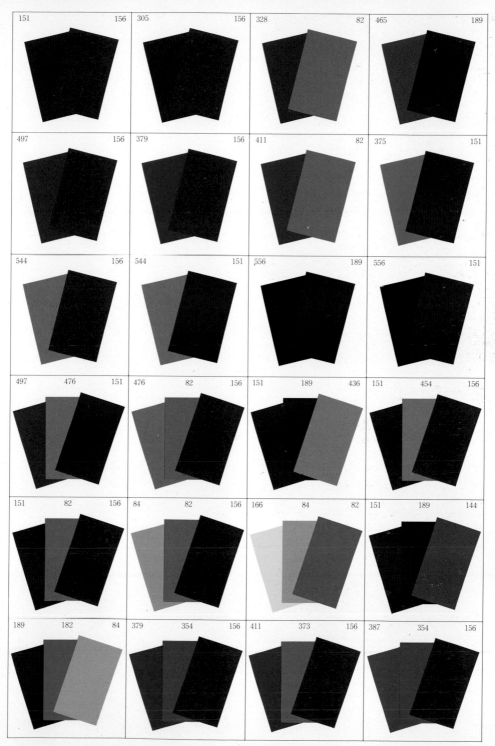

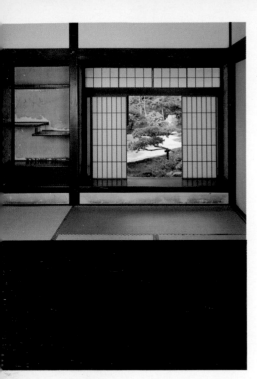

Natural

Natural colors are subtle, complicated hues — often dark and muted, never gaudy. In this photograph of a Japanese tearoom, no "artificial" colors are visible — only rice paper, unpainted wood, straw mats, and earthen walls. In the traditional Japanese arts, this color scheme is followed religiously: only natural pigments are used in paintings, and equally subtle and natural dyes are used to color textiles.

As you can see in the color samples at right, natural colors are complex combinations of many hues: for instance, dark brown is made from all three primary colors, as well as black. Since natural color schemes tend to look a little drab and lifeless, it's often helpful to include at least one brighter hue, like the soft green of foliage (as in the photograph), or a pale blue to suggest the sky. Don't make it too bright, or it will completely overwhelm your other colors!

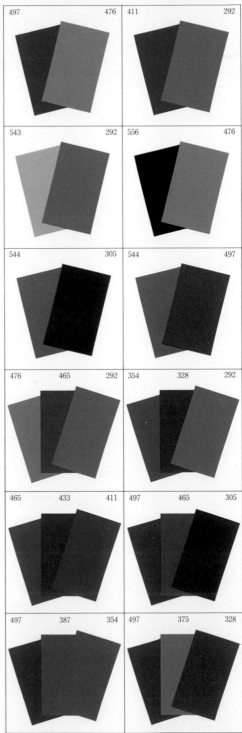

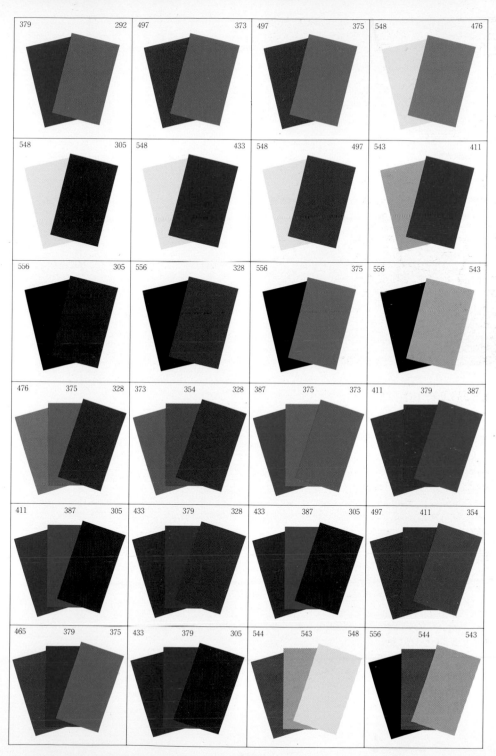

379 292 | 497 373 | 497 375 | 548 476

548 305 | 548 433 | 548 497 | 543 411

556 305 | 556 328 | 556 375 | 556 543

476 375 328 | 373 354 328 | 387 375 373 | 411 379 387

411 387 305 | 433 379 328 | 433 387 305 | 497 411 354

465 379 375 | 433 379 305 | 544 543 548 | 556 544 543

33

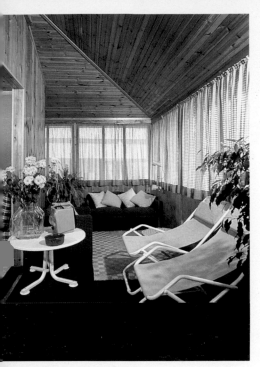

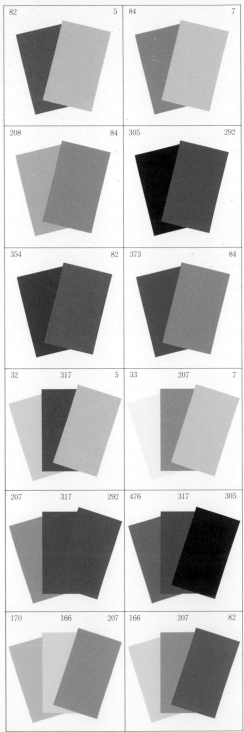

Warm

As you might expect, warm color schemes use warm colors like orange, yellow, pink, brown, and burgundy. They don't, however, use the king of the warm colors — red — which tends to make a color scheme look positively *hot*. Although green and gray are technically cool colors, when you add a tint of yellow to green or a reddish hue to gray, they can look warm too. Even blue can look warm when you give it a pale, greenish hue.

When you use cool colors in a warm color scheme, the warm hues will tend to overpower the cool ones. For instance, we can feel the warmth in the cypress walls, lace curtains, canvas seat colors, and chocolate brown furniture in this photograph, so the white tubular frames on the chairs and end table — which might look cold and forbidding in another setting — don't bother us. The bright yellow flowers also help to bring the green plants into the warm color scheme.

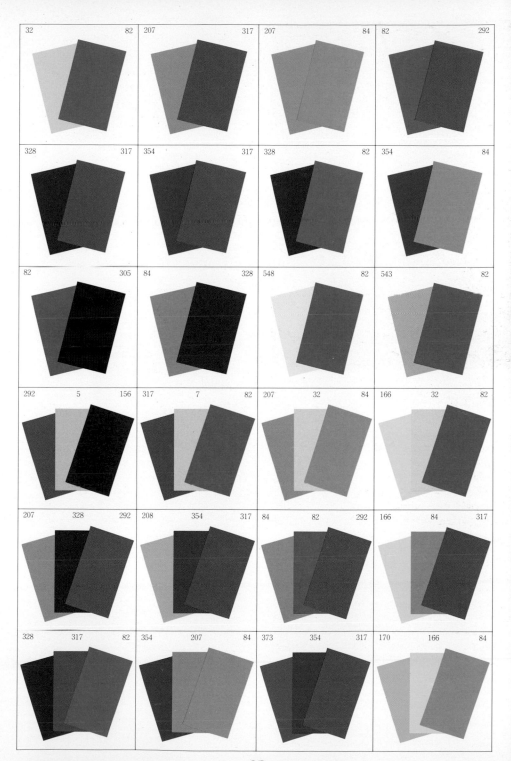

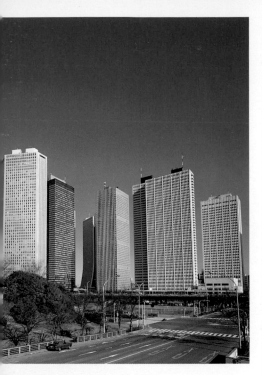

Cold

Cold color schemes use cool colors — green, blue, purple, and gray — to create a cold, forbidding impression. Cold color schemes remind us of artificial, man-made structures like skyscrapers, and bring to mind such unpleasant qualities as alienation, impersonality (remember that shade of institutional green used in high schools?), and loneliness. On the other hand, cold color schemes can be used to good effect in summer homes and bathrooms, where they look cool, refreshing, and "sanitary."

Dependable cool hues are pale, icy greens and blues, sky blue, aquamarine, dark green, and navy blue. Yellow-green and red-violet are borderline warm colors, and even one warm color will take away the cold effect (in this respect, a cold color scheme is very different from a warm color scheme, where cool hues are "absorbed" by the warm hues). The exception to this rule is pale pink, since pink is mostly white and white itself is a cool color.

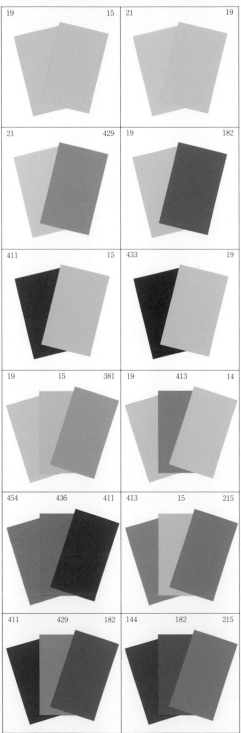

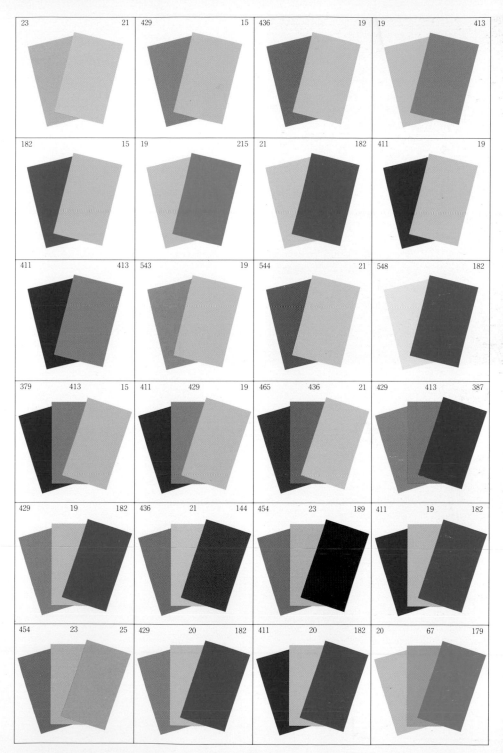

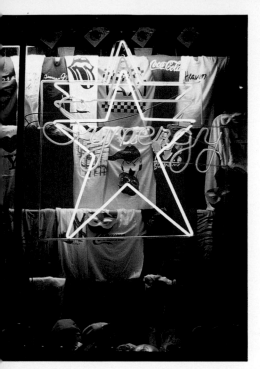

Young

The T-shirts in this store window are obviously meant to snare the young, but what in particular about the colors suggests "youth"? The fashions worn by the young change so quickly and so radically, it's almost impossible to point to a particular hue or combinations of hues and say, *"that's* young."

But whatever colors kids and teenagers (and adults who want to look young) are wearing at the moment, there are a few rules that remain constant. For one thing, the young tend to reject a safe middle ground (for instance, earth colors and pastels) in favor of extremes: colors that are either extremely bright, or extremely pale. Sharp contrasts, or almost no contrast at all. Powerful, energetic primary colors, or monotonous blacks and whites. Often the color schemes seem shocking to us — just like the messages on these T-shirts.

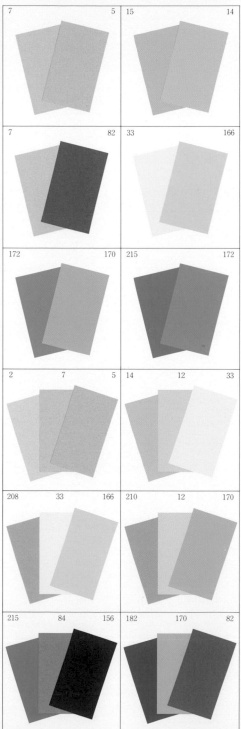

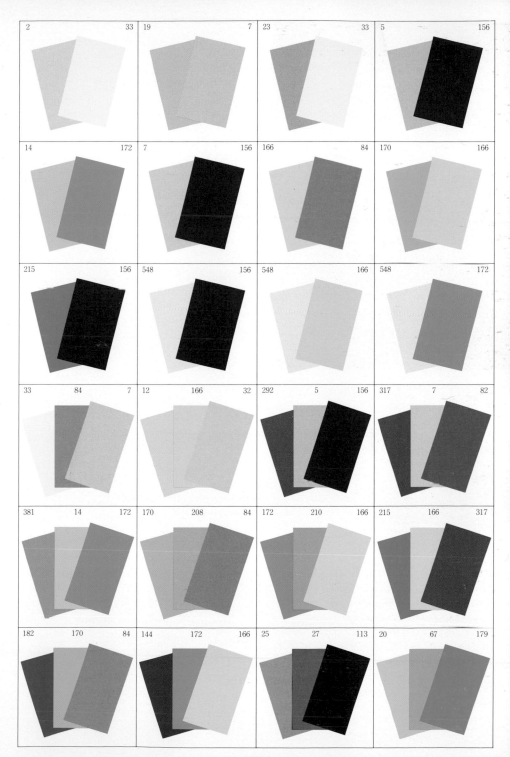

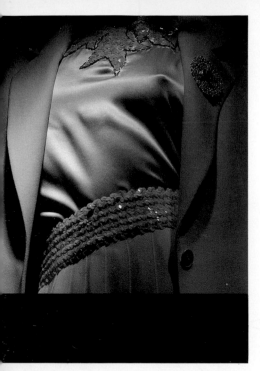

Feminine

The term "feminine" comes from another era, a time when it meant frilly white dresses with bright satin bows. Today, women's fashions use everything from soft pink and pale yellow to bold shades of red, gold, and black — color schemes that look eye-catching and chic, though not quite so startling as the color preferences of the young. Even women's business suits and "power outfits" are allowed a little more leeway than their male counterparts.

Since the colors in women's fashions change every season (we all remember the purple season a few years ago), it's difficult to make sweeping generalizations about feminine color schemes. Often, sharp contrasts are eschewed in favor of contrasting hues from the same color group — say, red with pink, or purple with lilac. When different color groups are mixed, the value or lightness tends to remain the same — for instance, light shades of blue with light shades of green.

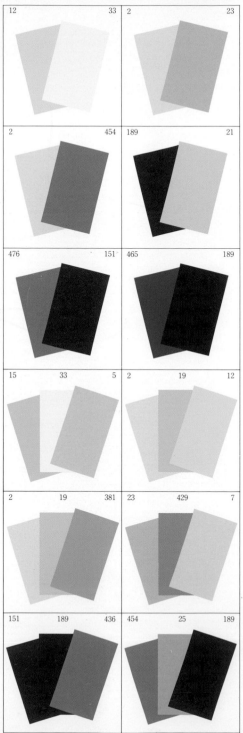

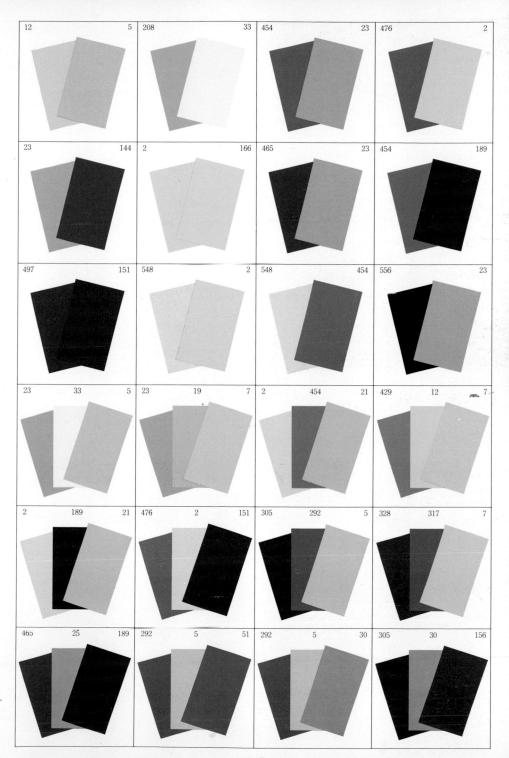

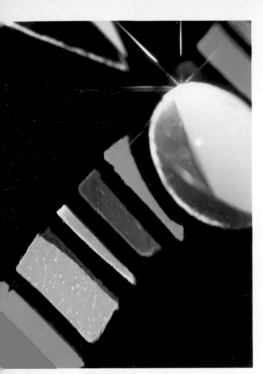

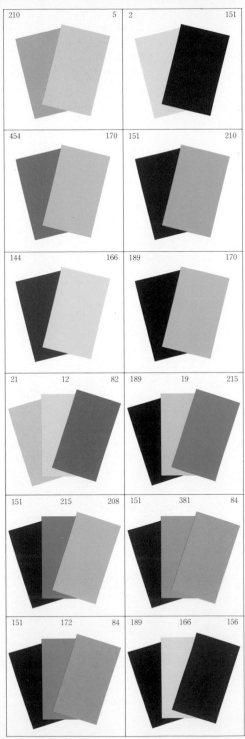

Surprising

What makes a color scheme look surprising? Colors and combinations of colors that we don't often see in everyday life. Some colors that we now consider fashionable — like the *Miami Vice* color scheme of pink and turquoise — looked strange and even ugly when we first saw them. In fact, almost any color scheme that you can think of will start to look familiar in time: the trick is to be the one who thinks of it *first*.

Three colors that we don't see very much of in nature are the process colors: magenta, yellow, and cyan. As in this photograph, color schemes which use the process colors will tend to seem startling and unconventional (a lot of "new wave" designs use these colors). In addition, hues that run contrary to their natural brightness (for instance, dark yellow and orange, very pale blue and green) tend to look surprising, as do color schemes which do not take contrast into consideration: blue with green, magenta with purple, magenta with red.

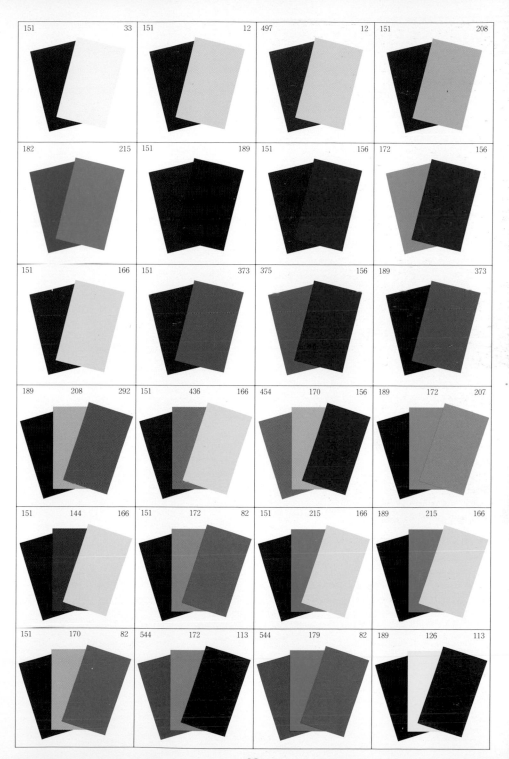

43

Color Con

Now we come to the heart of this book: the 1,662 different combinations of two, three, or four of the 61 basic colors. This section expands and elaborates on the color schemes on *pages 26-43*, and in it you'll find color combinations for almost any purpose — even some combinations that you wouldn't want to use very often.

● The color combinations on *pages 46-94* are arranged according to the color relationships on the color wheel (*see page 10*); for instance, *similar hues* and *complementary hues* are grouped together. Within each section, the color combinations are arranged according to the four color groups on the basic color table: light colors, dull colors, vivid colors, and dark colors (*see pages 8-9*).

● The color combinations on *pages 95-119* are selected and arranged in order to convey a specific color impression, or bring to mind a certain emotion; for instance, *natural colors* or *Japanese colors*.

● Each color combination is arranged in a fan shape so that you can easily compare each color with every other color. The *dominant color* is always on the right, and the *subordinate color* or colors on the left. In general, the dominant color should be used sparingly; for instance, on a book cover, the dominant color might be used for the display type, and the subordinate color for the background.

● Each color is identified by its Dai Nippon Ink Color (*DIC*) number, and each color combination is also identified by number; for instance, the color combinations in the *same hue* section are numbered from *1-1* to *1-120*.

● The symbols ▶ and ● indicate the boundaries of a group of related color combinations; for instance, color combinations *1-1* to *1-11* each consist of a light color from the basic color table paired with a dull color of the same hue.

To use these color combinations, first find the photograph on *pages 26-43* that most closely resembles the color scheme that you're looking for. Then look at the sample color combinations to the right of the photograph. Do the combinations use warm colors or cool colors, similar hues or contrasting hues, bright primary colors or dull secondary colors? Keep these qualities in mind as you leaf through the pages of this section, and look for an appropriate color scheme, or simply a page of colors that catches your eye and seems to convey the right image. The caption at the bottom of the page may help you to narrow your search even further.

binations

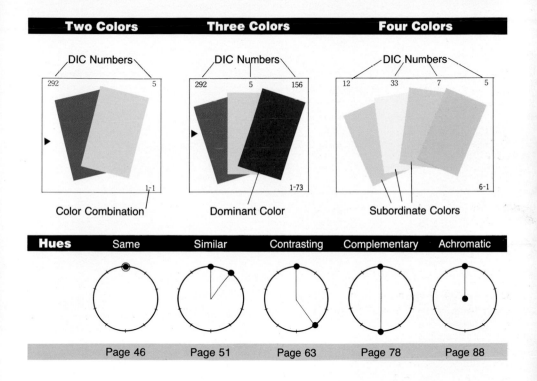

Two Colors	Three Colors	Four Colors

DIC Numbers

292 5

Color Combination

1-1

DIC Numbers

292 5 156

Dominant Color

1-73

DIC Numbers

12 33 7 5

Subordinate Colors

6-1

Hues	Same	Similar	Contrasting	Complementary	Achromatic
	Page 46	Page 51	Page 63	Page 78	Page 88

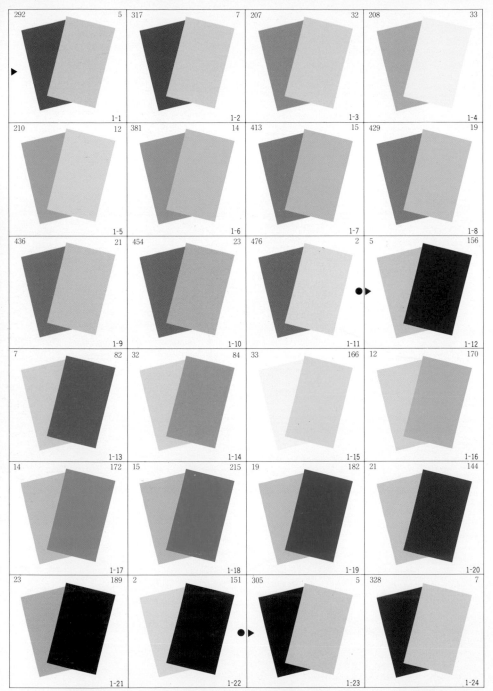

292	5	317	7	207	32	208	33
1-1		1-2		1-3		1-4	

210	12	381	14	413	15	429	19
1-5		1-6		1-7		1-8	

436	21	454	23	476	2	5	156
1-9		1-10		1-11		1-12	

7	82	32	84	33	166	12	170
1-13		1-14		1-15		1-16	

14	172	15	215	19	182	21	144
1-17		1-18		1-19		1-20	

23	189	2	151	305	5	328	7
1-21		1-22		1-23		1-24	

● **Same Hue** These two- and three-color combinations are variations on a single hue. Within each color combination, all of the colors would occupy the same position on the color wheel, or would come from the same column on the basic color table.

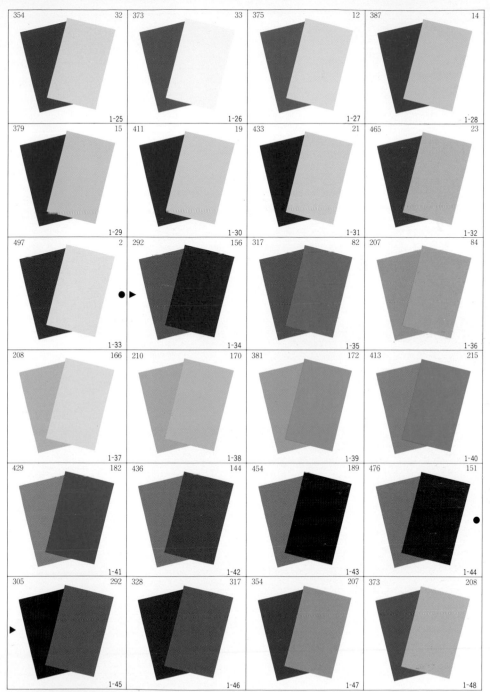

In color combinations *1-1* to *1-11*, the color on the *right* is a light color, and the color on the *left* is a dull color with the same hue. *1-12* to *1-22* are vivid colors with light colors, *1-23* to *1-33* are light colors with dark colors, *1-34* to *1-44* are vivid colors with dull colors, and *1-45* to *1-55* are dull colors with dark colors.

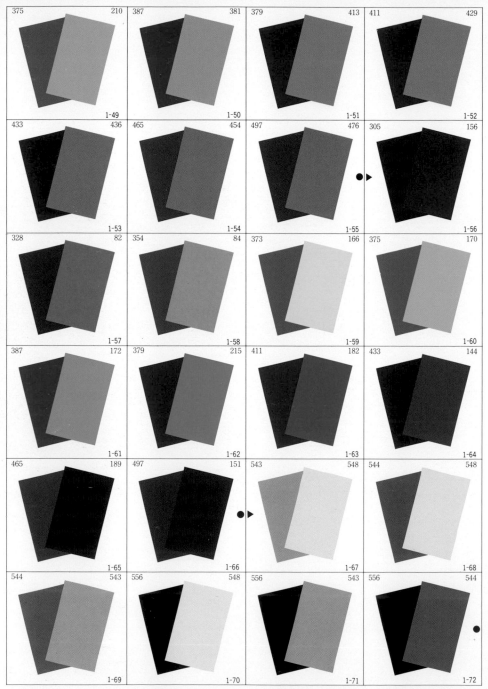

375	210	387	381	379	413	411	429
	1-49		1-50		1-51		1-52
433	436	465	454	497	476	305	156
	1-53		1-54		1-55		1-56
328	82	354	84	373	166	375	170
	1-57		1-58		1-59		1-60
387	172	379	215	411	182	433	144
	1-61		1-62		1-63		1-64
465	189	497	151	543	548	544	548
	1-65		1-66		1-67		1-68
544	543	556	548	556	543	556	544
	1-69		1-70		1-71		1-72

Combinations *1-56* to *1-66* are vivid colors with dark colors. *1-67* to *1-72* are shades of gray and black. These two-color combinations might be appropriate for the background color and the display type when you want a unified effect.

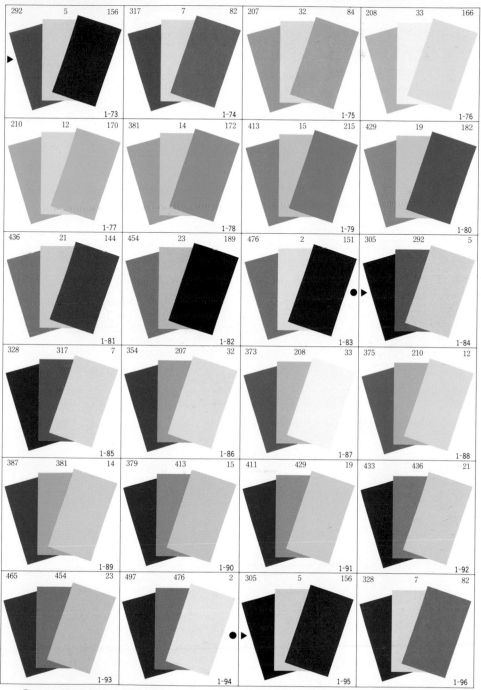

These three-color combinations work beautifully together: since they all share the same hue, there's no discord. Combinations *1-73* to *1-83* show vivid colors (*right*) with light colors (*center*) and dull colors (*left*); *1-84* to *1-94* are light colors with dull and dark colors.

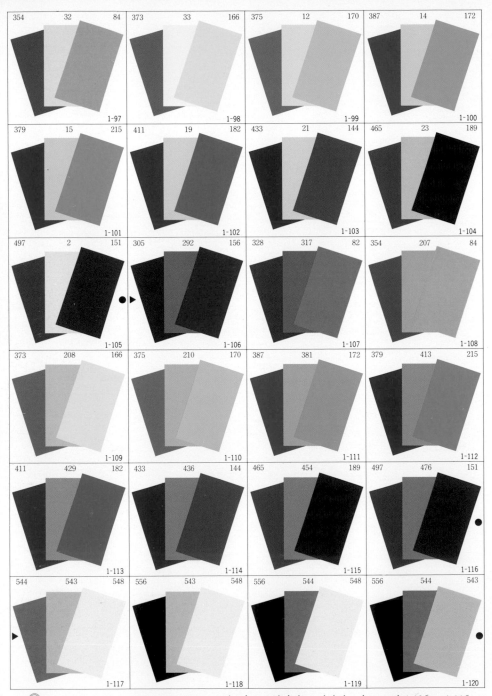

1-95 to *1-105* are vivid colors with light and dark colors, and *1-106* to *1-116* are vivid colors with dull and dark colors. (When a vivid color is dominant, use it sparingly.) By varying the order of the colors, you can achieve variety and rhythm.

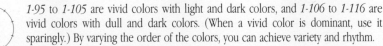

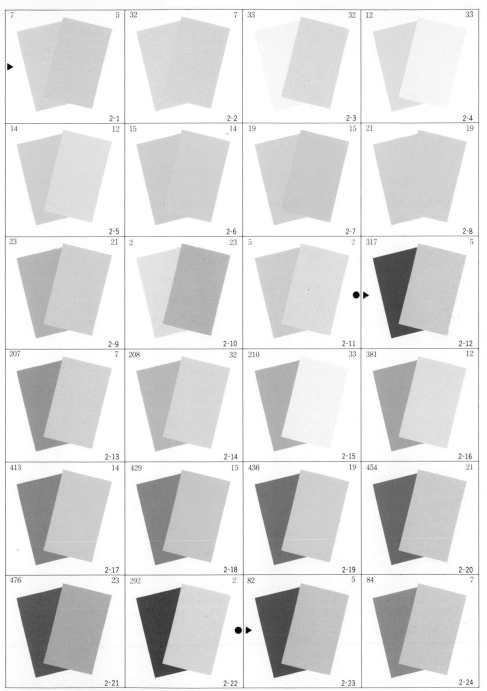

● **Similar Hues** Hues that are adjacent on the color wheel, or occupy adjacent columns on the basic color table, are similar hues: they clearly have a lot in common (like red and orange, or green and blue-green), but there is still a feeling of tension between them.

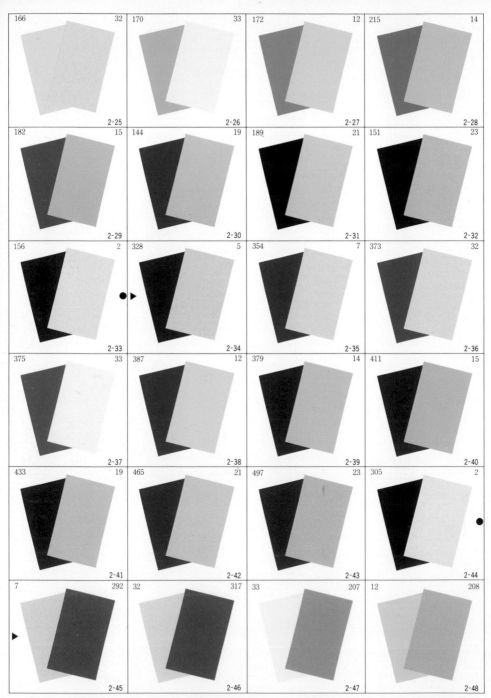

166 32 2-25	170 33 2-26	172 12 2-27	215 14 2-28
182 15 2-29	144 19 2-30	189 21 2-31	151 23 2-32
156 2 2-33	328 5 2-34	354 7 2-35	373 32 2-36
375 33 2-37	387 12 2-38	379 14 2-39	411 15 2-40
433 19 2-41	465 21 2-42	497 23 2-43	305 2 2-44
7 292 2-45	32 317 2-46	33 207 2-47	12 208 2-48

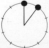 Combinations *2-1* through *2-44* use light colors as the dominant color. *2-1* to *2-11* pair light colors with similar light colors, which makes for almost no contrast and poor color harmony. From *2-12* to *2-44*, the hues are similar but the shade varies, so they blend better.

52

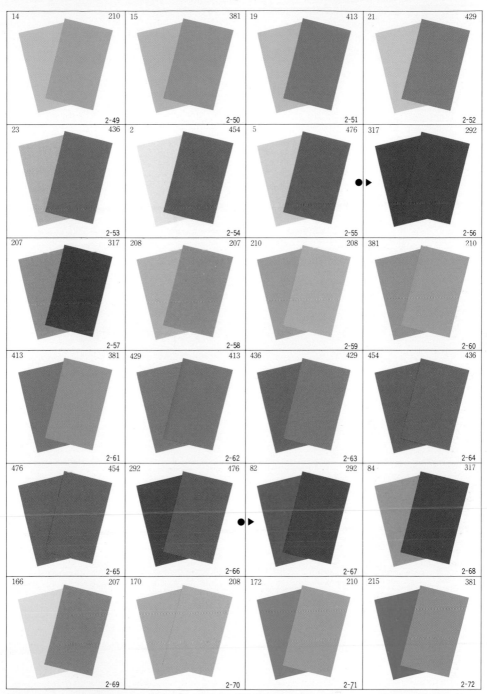

Color schemes using light colors look relaxed and well-balanced, and are often seen in fashion, interior design, packaging, and book jackets (the light color usually makes a better background color). Light colors look fresh and springlike, particularly when paired with dull colors (*2-12* to *2-22*).

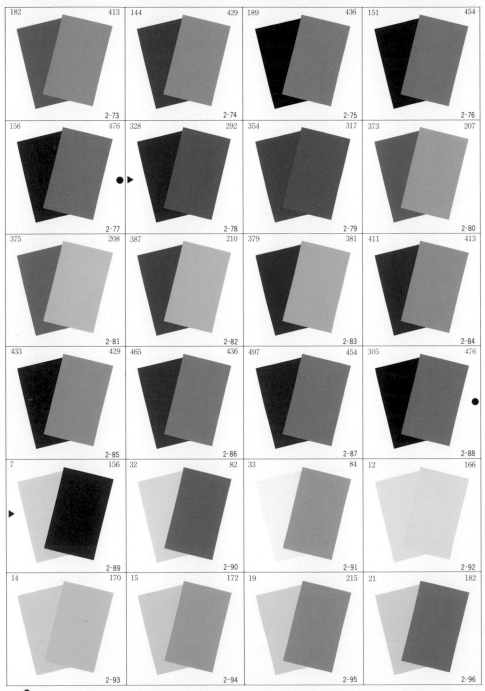

182 — 413 (2-73)	144 — 429 (2-74)	189 — 436 (2-75)	151 — 454 (2-76)
156 — 476 (2-77)	328 — 292 (2-78)	354 — 317 (2-79)	373 — 207 (2-80)
375 — 208 (2-81)	387 — 210 (2-82)	379 — 381 (2-83)	411 — 413 (2-84)
433 — 429 (2-85)	465 — 436 (2-86)	497 — 454 (2-87)	305 — 476 (2-88)
7 — 156 (2-89)	32 — 82 (2-90)	33 — 84 (2-91)	12 — 166 (2-92)
14 — 170 (2-93)	15 — 172 (2-94)	19 — 215 (2-95)	21 — 182 (2-96)

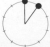

Combinations *2-45* to *2-88* use dull colors as the dominant color, and when dull colors are mixed with similar dull colors (*2-56* to *2-66*), the contrast is minimal. Dull colors have a wistful, autumn-like quality, and look best when paired with dark colors (*2-78* to *2-88*).

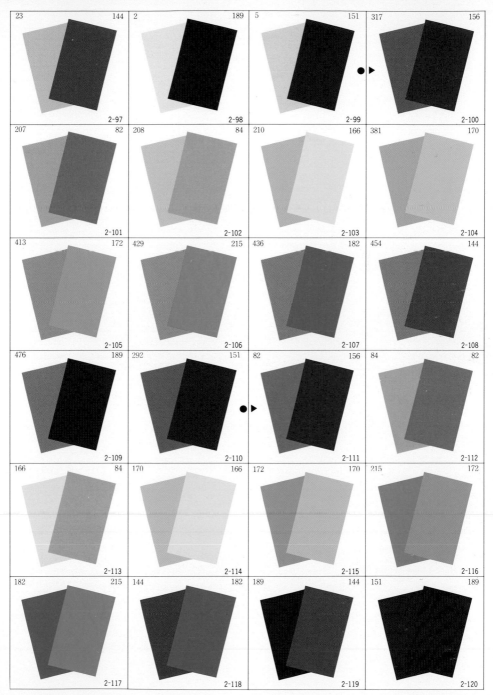

Combinations *2-89* to *2-132* use vivid colors as the dominant color. Vivid colors paired with light colors (*2-89* to *2-99*) look bright and summery. However, when you combine vivid colors with similar vivid colors (*2-111* to *2-121*), the effect can be quite jarring (*2-118* to *2-121* are particularly bad color schemes).

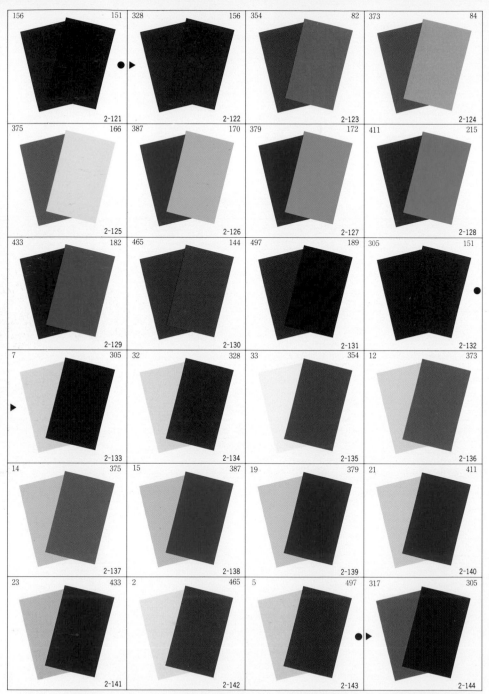

Finally, combinations *2-133* to *2-168* use dark colors as the dominant color. *2-133* to *2-143* are examples of mediocre harmony, since either color could be the dominant color. To round out the seasons, combinations of dark and dull colors (*2-144* to *2-154*) look somber and wintery.

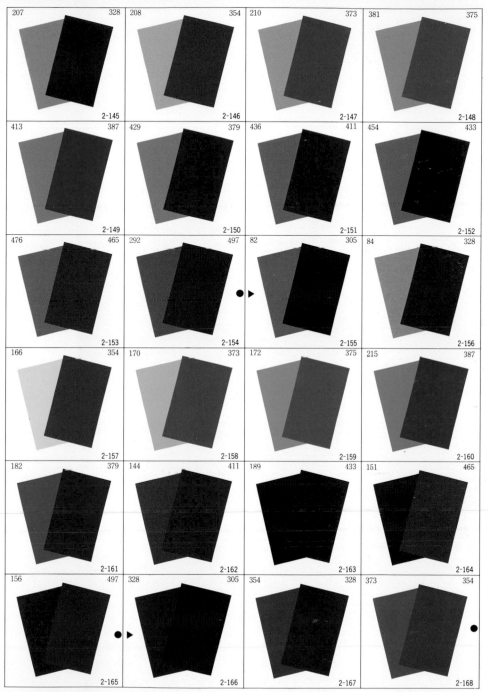

Combinations *2-155* to *2-165* make vivid colors subordinate to dark colors, a color scheme which will make your designs look elegant and understated: perfect for annual reports, product brochures, or corporate identity programs. Combinations *2-166* to *2-168* (similar dark colors) once again show very little contrast.

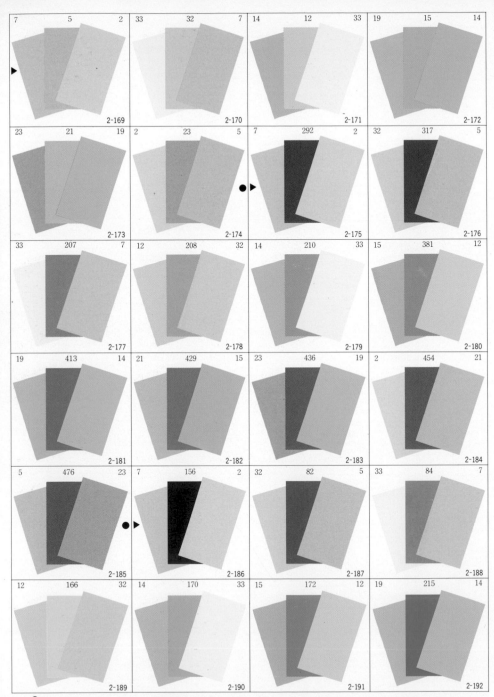

These three-color combinations also use colors with similar hues. Combinations *2-169* to *2-174* use three light colors, so the level of harmony is low. But when a dull color (*2-175* to *2-185*) or a vivid color (*2-186* to *2-196*) is added, the color harmony is greatly improved.

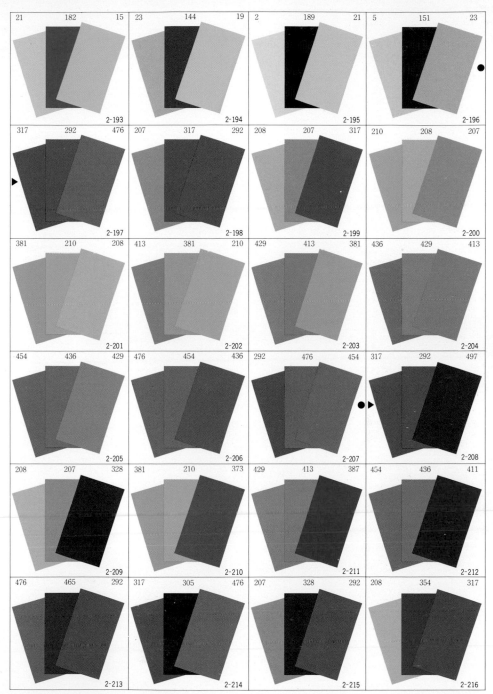

Beginning with *2-197*, the combinations are based on dull colors. *2-197* to *2-207* use three dull colors, which results in little contrast and a rather boring effect. From *2-208* to *2-224*, a much more elegant effect is created by adding a dark color to the two dull colors (see how bright the green looks in *2-220*).

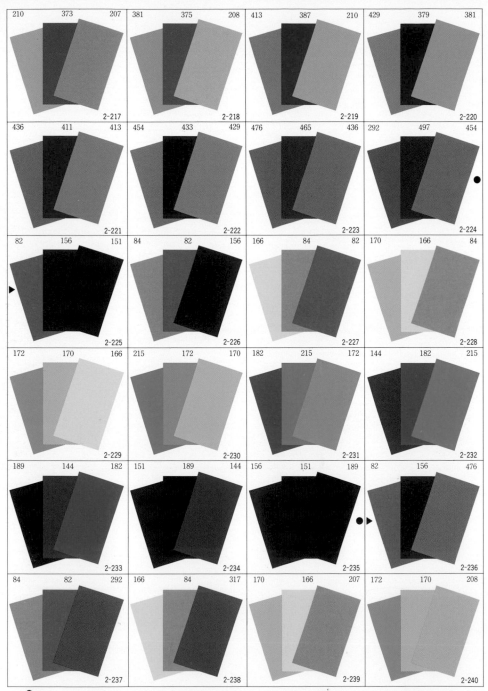

210	373	207
2-217

381	375	208
2-218

413	387	210
2-219

429	379	381
2-220

436	411	413
2-221

454	433	429
2-222

476	465	436
2-223

292	497	454
2-224

82	156	151
2-225

84	82	156
2-226

166	84	82
2-227

170	166	84
2-228

172	170	166
2-229

215	172	170
2-230

182	215	172
2-231

144	182	215
2-232

189	144	182
2-233

151	189	144
2-234

156	151	189
2-235

82	156	476
2-236

84	82	292
2-237

166	84	317
2-238

170	166	207
2-239

172	170	208
2-240

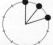

Combinations *2-225* to *2-268* are based on vivid colors, which is in itself a problem, since vivid colors tend to overwhelm and confuse our color sense. *2-225* to *2-235* use three vivid colors with similar hues in a *portamento* effect: a smooth transition from color to color, like a rainbow.

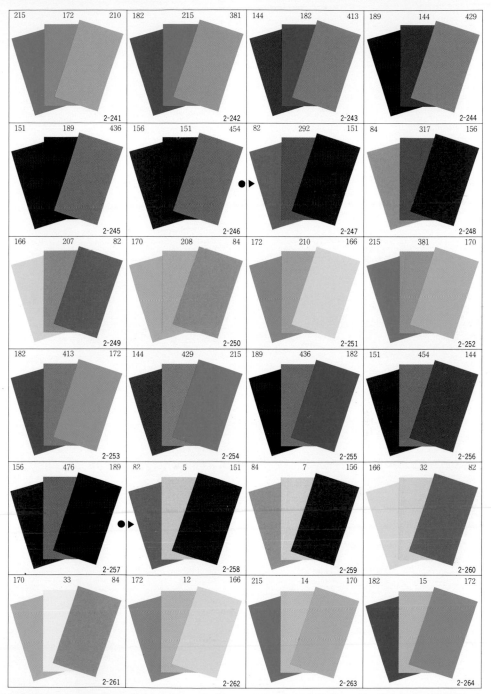

A much more harmonious effect can be attained by separating the vivid colors with a light color (*2-258* to *2-268*). To keep the two vivid colors from clashing (and your graphic design from looking gaudy), use the light color as the background color, or as an "accent stripe" between the two vivid colors.

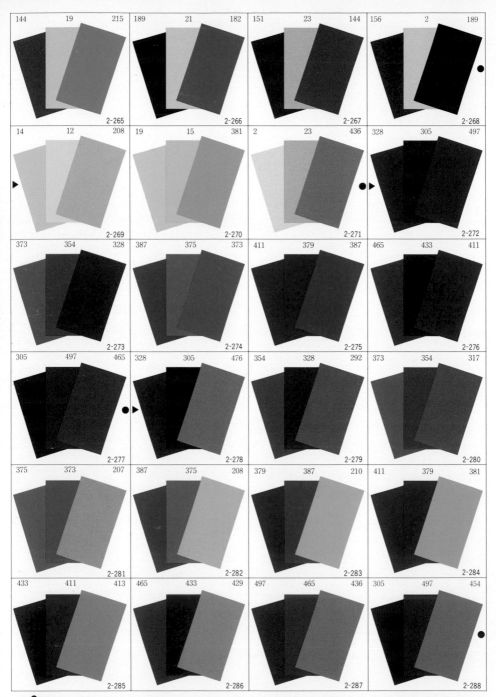

2-265 144 19 215

2-266 189 21 182

2-267 151 23 144

2-268 156 2 189

2-269 14 12 208

2-270 19 15 381

2-271 2 23 436

2-272 328 305 497

2-273 373 354 328

2-274 387 375 373

2-275 411 379 387

2-276 465 433 411

2-277 305 497 465

2-278 328 305 476

2-279 354 328 292

2-280 373 354 317

2-281 375 373 207

2-282 387 375 208

2-283 379 387 210

2-284 411 379 381

2-285 433 411 413

2-286 465 433 429

2-287 497 465 436

2-288 305 497 454

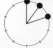

2-269 to *2-271*, which use two light colors and a dull color, blend nicely. *2-272* to *2-277* — three dark colors — lack contrast and are fairly boring; even the addition of a dull color (*2-278* to *2-288*) doesn't help them much (which proves that not all similar colors look nice together).

62

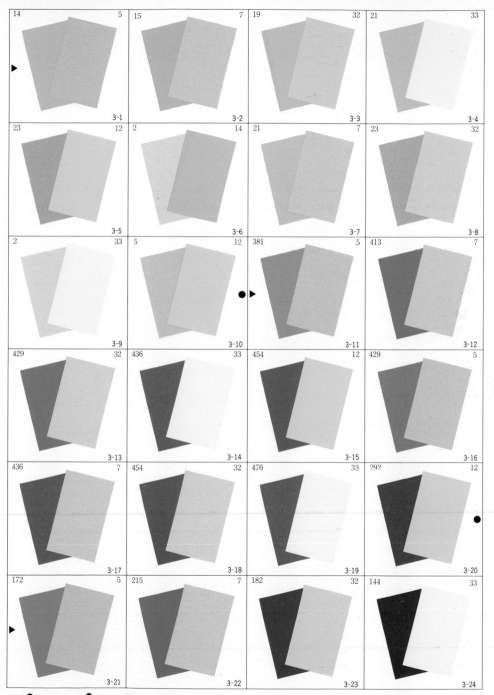

● Contrasting Hues Hues that have three colors between them on the color wheel are contrasting hues. Despite the name, they can blend quite well together; even *3-1* to *3-10*, which use two light colors, look harmonious.

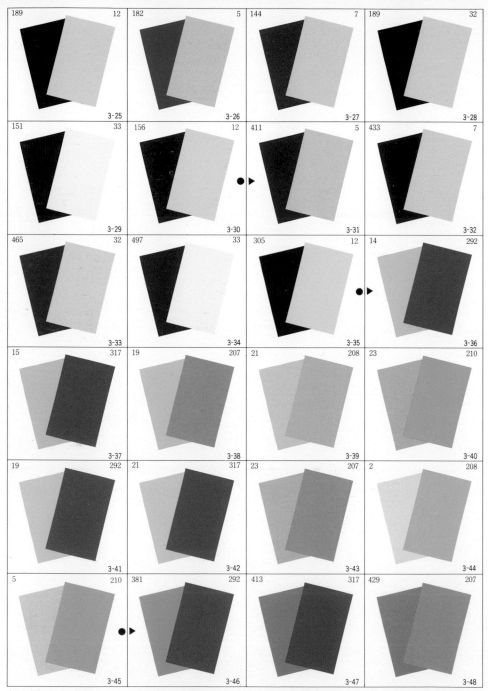

From *3-11* to *3-20*, the contrast between light and dull colors makes the hues even more harmonious. But *3-21* to *3-30* (contrasting light and vivid colors) and *3-31* to *3-35* (light and dark colors) begin to show too much contrast.

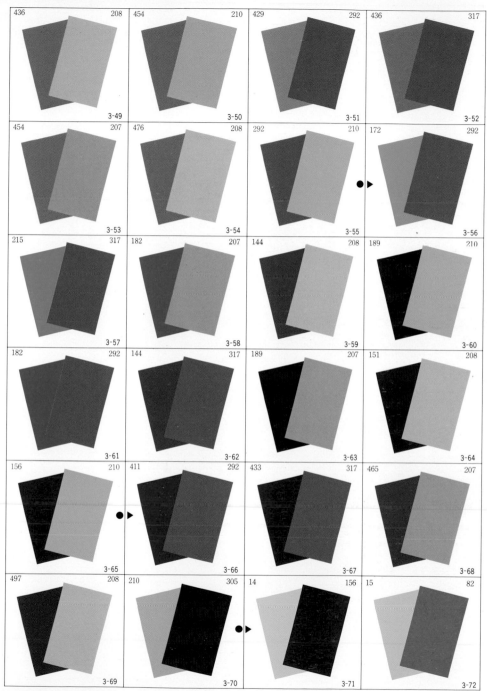

Combinations *3-36* to *3-70* use dull colors, which work best when contrasted with other dull colors (*3-46* to *3-55*), or with vivid colors (*3-56* to *3-65*). These color combinations remind us of the sky, the earth, trees, and flowers — in other words, the colors in nature. (Purple is the only color here not commonly found in nature.)

65

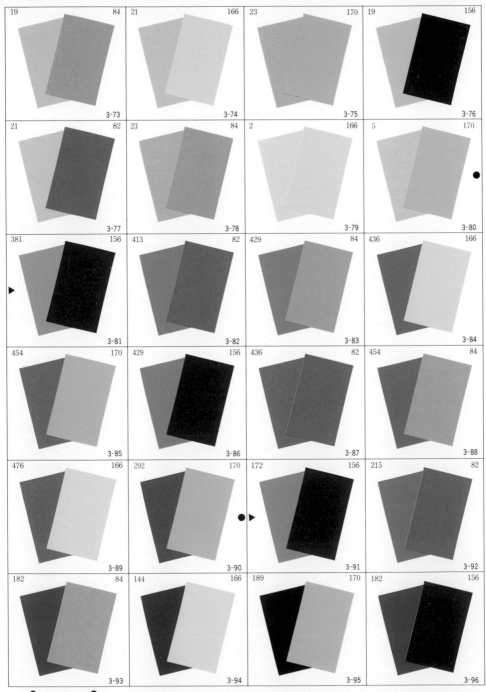

19 · 84 · 3-73	21 · 166 · 3-74	23 · 170 · 3-75	19 · 156 · 3-76
21 · 82 · 3-77	23 · 84 · 3-78	2 · 166 · 3-79	5 · 170 · 3-80
381 · 156 · 3-81	413 · 82 · 3-82	429 · 84 · 3-83	436 · 166 · 3-84
454 · 170 · 3-85	429 · 156 · 3-86	436 · 82 · 3-87	454 · 84 · 3-88
476 · 166 · 3-89	292 · 170 · 3-90	172 · 156 · 3-91	215 · 82 · 3-92
182 · 84 · 3-93	144 · 166 · 3-94	189 · 170 · 3-95	182 · 156 · 3-96

Depending on the hues, some color combinations that use contrasting vivid colors are extremely easy to read (such as *3-76, 3-77, 3-83,* and *3-84*), but others lack contrast and would be difficult to distinguish (such as *3-79, 3-82,* and *3-87*).

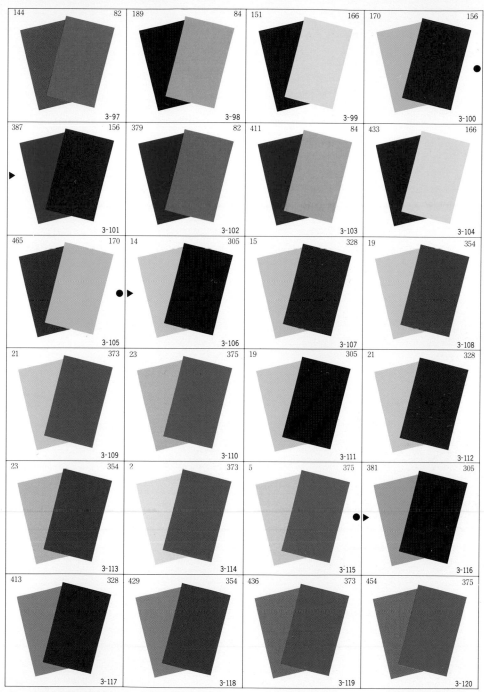

The color combinations from *3-91* to *3-100*, which use two contrasting vivid colors, look awkward and restless, since the hues are almost — but not quite — complementary. Combinations *3-101* to *3-105*, which use one vivid color and one dark color, are a little easier to look at, but still not particularly elegant.

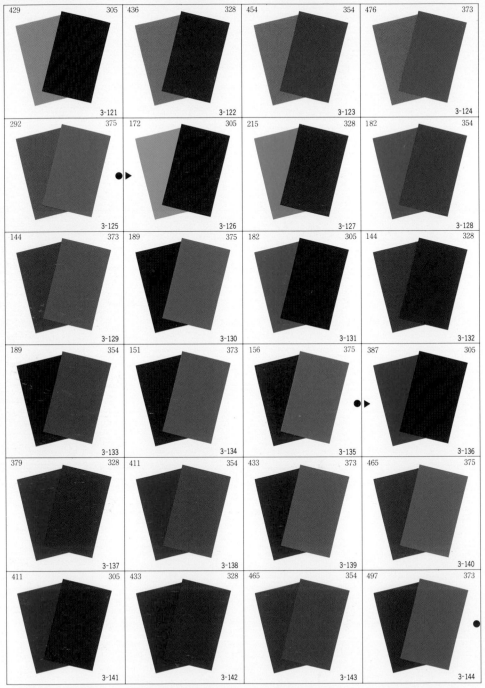

3-106 to 3-144, which use dark colors, are quite ugly, and should be avoided for commercial purposes. 3-136 to 3-144, which use contrasting dark colors, at least have a certain dour elegance, and are often seen in men's clothing.

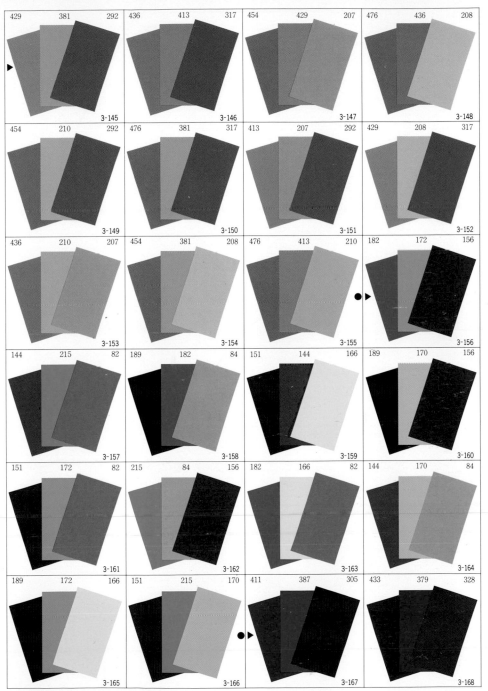

429	381	292	3-145
436	413	317	3-146
454	429	207	3-147
476	436	208	3-148
454	210	292	3-149
476	381	317	3-150
413	207	292	3-151
429	208	317	3-152
436	210	207	3-153
454	381	208	3-154
476	413	210	3-155
182	172	156	3-156
144	215	82	3-157
189	182	84	3-158
151	144	166	3-159
189	170	156	3-160
151	172	82	3-161
215	84	156	3-162
182	166	82	3-163
144	170	84	3-164
189	172	166	3-165
151	215	170	3-166
411	387	305	3-167
433	379	328	3-168

Three-color combinations of contrasting hues present a problem, since two of the hues will always fall fairly close together on the color wheel — almost, but not quite, similar. As a result, the three colors seem to fly off in random directions, leaving the color scheme confused and off-balance.

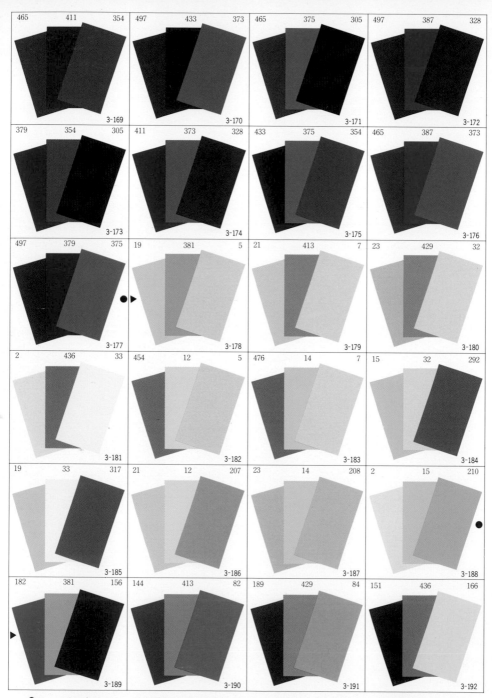

465	411	354	497	433	373	465	375	305	497	387	328
		3-169			3-170			3-171			3-172
379	354	305	411	373	328	433	375	354	465	387	373
		3-173			3-174			3-175			3-176
497	379	375	19	381	5	21	413	7	23	429	32
		3-177			3-178			3-179			3-180
2	436	33	454	12	5	476	14	7	15	32	292
		3-181			3-182			3-183			3-184
19	33	317	21	12	207	23	14	208	2	15	210
		3-185			3-186			3-187			3-188
182	381	156	144	413	82	189	429	84	151	436	166
		3-189			3-190			3-191			3-192

 Combinations of three contrasting vivid colors (*3-156* to *3-166*) show little harmony, but seem cheerful when used for sportswear or outdoor events like the 1984 Olympic Games. Three dark colors (*3-167* to *3-177*) do not balance any better than three dull colors or three vivid colors.

70

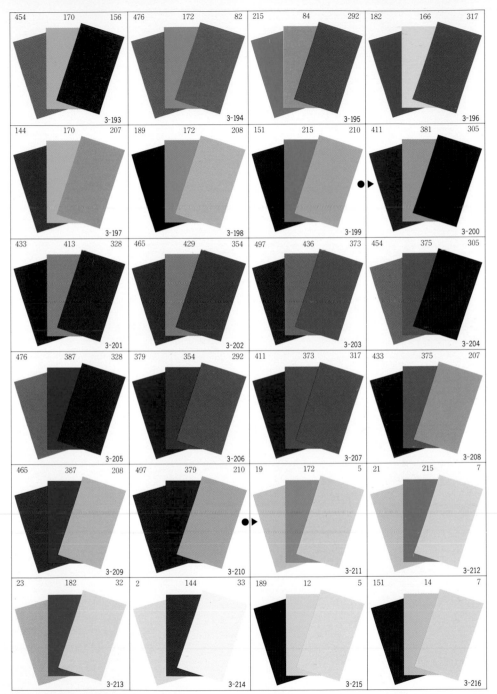

When a different shade is used as an accent, the harmony is vastly improved. Here we have a dull color with: two light colors (*3-178* to *3-188*), two vivid colors (*3-189* to *3-199*), and two dark colors (*3-200* to *3-210*); and a vivid color with: two light colors (*3-211* to *3-218*), and two dull colors (*3-219* to *3-229*).

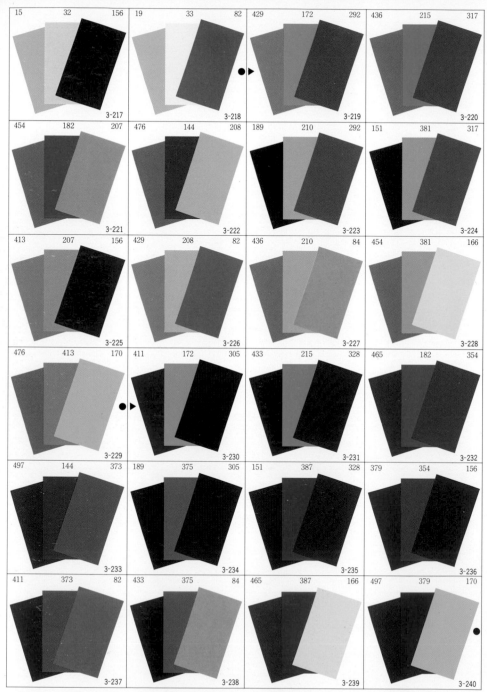

When you use a vivid color as the dominant color and two dark colors as the subordinate colors (*3-230* to *3-240*), the vivid color can draw the individual hues together, and lend some harmony to even the most chaotic mixture of hues. As always, use the vivid color sparingly!

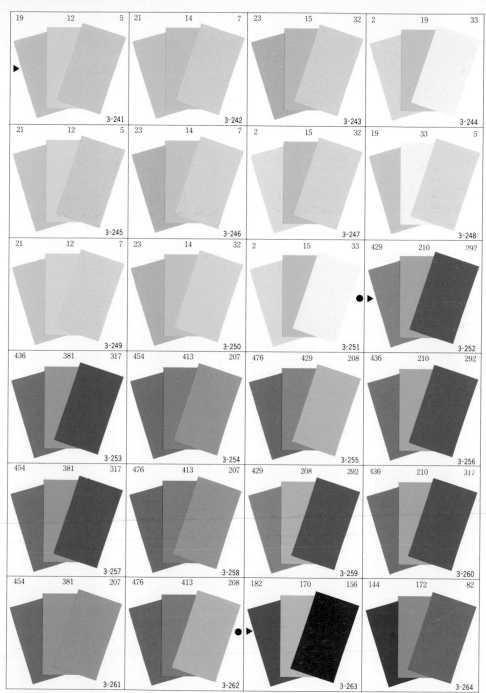

19 12 5	21 14 7	23 15 32	2 19 33
3-241	3-242	3-243	3-244

21 12 5	23 14 7	2 15 32	19 33 5
3-245	3-246	3-247	3-248

21 12 7	23 14 32	2 15 33	429 210 292
3-249	3-250	3-251	3-252

436 381 317	454 413 207	476 429 208	436 210 292
3-253	3-254	3-255	3-256

454 381 317	476 413 207	429 208 292	436 210 317
3-257	3-258	3-259	3-260

454 381 207	476 413 208	182 170 156	144 172 82
3-261	3-262	3-263	3-264

The color combinations beginning with *3-241* have a slightly different color relationship: two of the colors are contrasting, and the third color is halfway between the first two on the color wheel. The almost equal interval between each of the hues makes for a more balanced color scheme.

73

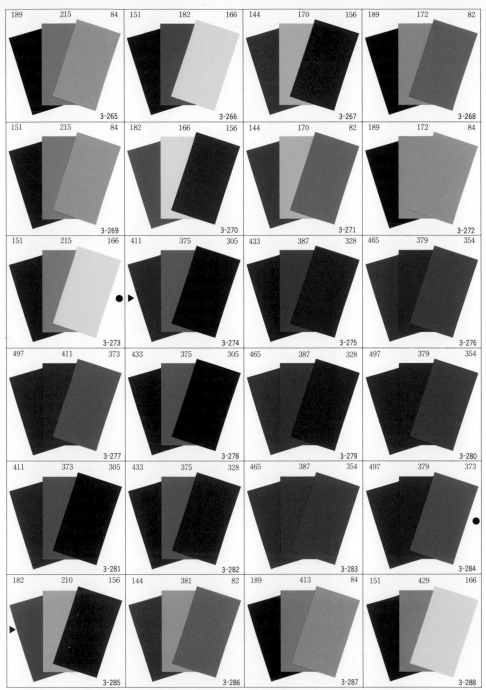

As we can see in combinations *3-241* to *3-284*, three colors with the same shade (for instance, three light colors) simply do not blend, no matter how evenly balanced the hues may be. But if you make even one color lighter or darker, as in *3-285* to *3-349*, harmony can be achieved.

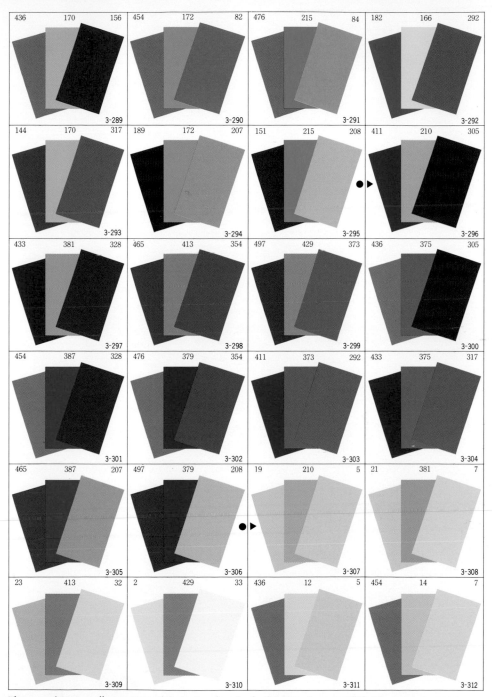

These combinations illustrate one of the basic rules of color harmony (*see page 138*): it's more important to vary the shade than to vary the hue. A color scheme that contrasts light colors with dark colors will look good with almost any hues; for instance, *3-296* to *3-306* look harmonious while *3-274* to *3-284* don't.

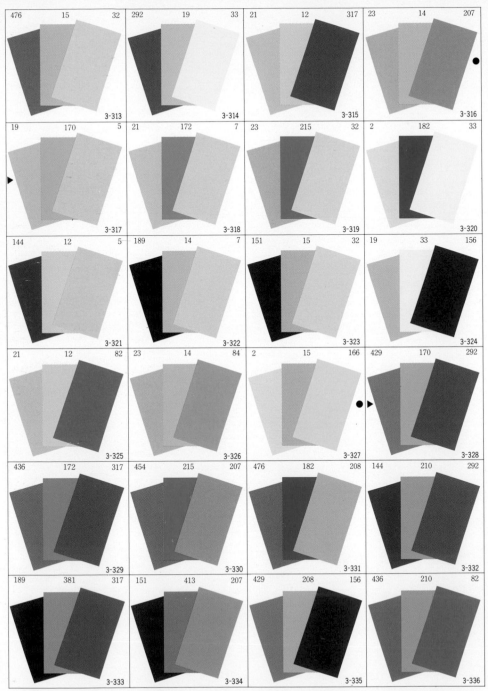

476	15	32	292	19	33	21	12	317	23	14	207
		3-313			3-314			3-315			3-316

19	170	5	21	172	7	23	215	32	2	182	33
		3-317			3-318			3-319			3-320

144	12	5	189	14	7	151	15	32	19	33	156
		3-321			3-322			3-323			3-324

21	12	82	23	14	84	2	15	166	429	170	292
		3-325			3-326			3-327			3-328

436	172	317	454	215	207	476	182	208	144	210	292
		3-329			3-330			3-331			3-332

189	381	317	151	413	207	429	208	156	436	210	82
		3-333			3-334			3-335			3-336

Color combinations that use one vivid color with two contrasting light colors (3-317 to 3-327 — compare the combinations with three light colors, 3-241 to 3-251) are particularly effective, and have a breezy, post-modern look that's perfect for book covers, magazines, or poster designs.

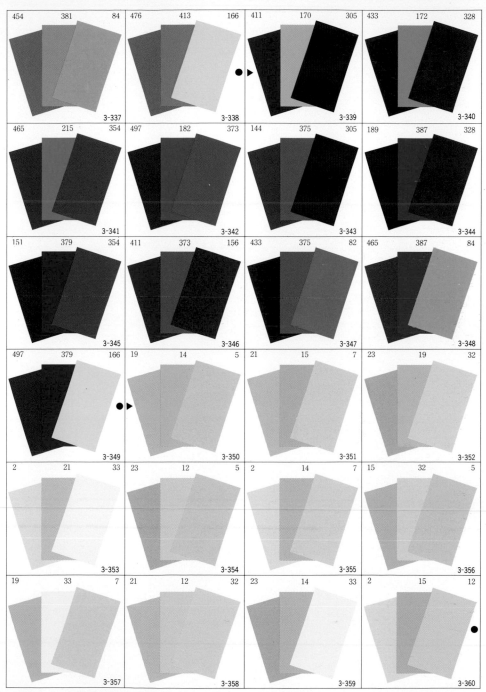

454	381	84	476	413	166	411	170	305	433	172	328

3-337 | 3-338 | 3-339 | 3-340

| 465 | 215 | 354 | 497 | 182 | 373 | 144 | 375 | 305 | 189 | 387 | 328 |

3-341 | 3-342 | 3-343 | 3-344

| 151 | 379 | 354 | 411 | 373 | 156 | 433 | 375 | 82 | 465 | 387 | 84 |

3-345 | 3-346 | 3-347 | 3-348

| 497 | 379 | 166 | 19 | 14 | 5 | 21 | 15 | 7 | 23 | 19 | 32 |

3-349 | 3-350 | 3-351 | 3-352

| 2 | 21 | 33 | 23 | 12 | 5 | 2 | 14 | 7 | 15 | 32 | 5 |

3-353 | 3-354 | 3-355 | 3-356

| 19 | 33 | 7 | 21 | 12 | 32 | 23 | 14 | 33 | 2 | 15 | 12 |

3-357 | 3-358 | 3-359 | 3-360

Oddly enough, combinations of three light colors (*3-350* to *3-360*) work best when the intervals between the hues are not equal, perhaps because we need some additional contrast between these very light hues. Colors like these are often found on spring clothing, sheets, and bathroom items.

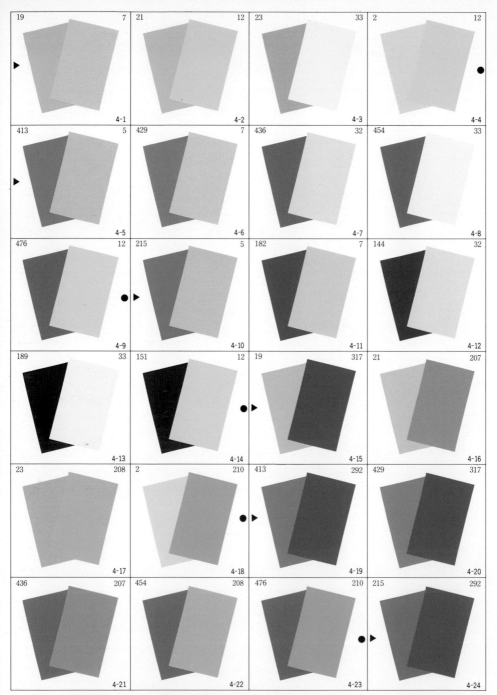

● **Complementary Hues** Complementary hues are on opposite sides of the color wheel — they "complement" each other, since between them they contain all the colors in the spectrum. (If you put complementary colors on a wheel and spin it very fast, they will turn to gray.)

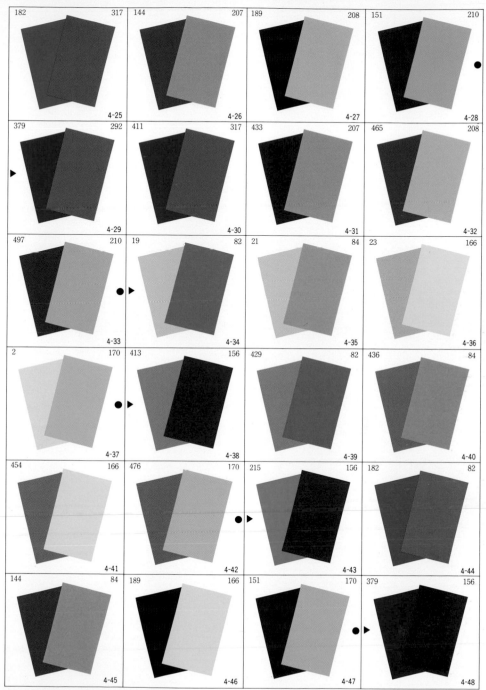

These two-color combinations have a nice sense of harmony, even when they use two light colors (*4-1* to *4-4*). As the colors get darker, contrast becomes more important: two dull colors (*4-19* to *4-23*) look distracting, and two vivid colors (such as *4-43* and *4-44*) create such tension that the border between them "vibrates."

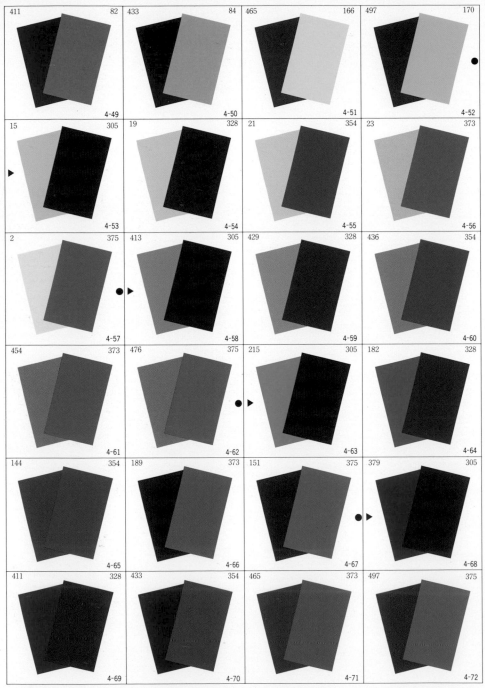

Dark colors with complementary light or dull colors (*4-53* to *4-62*) are also quite nice, if a little old-fashioned. On the other hand, dark colors with vivid colors, or two dark colors, look harsh and unpleasant together (*4-63* to *4-72*) — too much contrast in hue and not enough in shade.

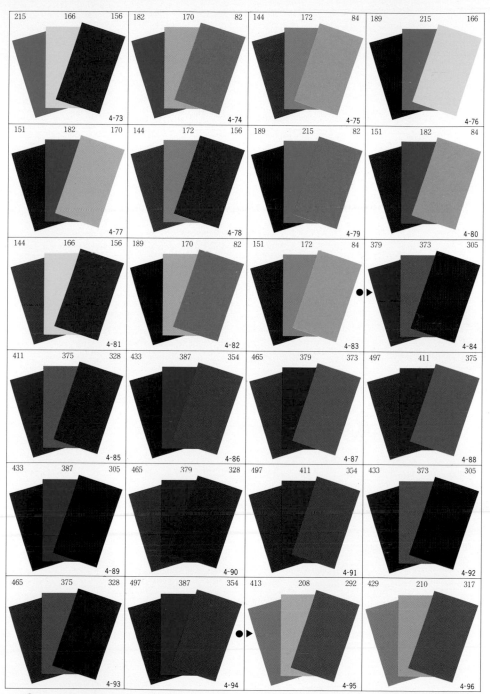

These three-color combinations use two complementary hues along with a third color that's halfway between the first two on the color wheel. The effect is somewhat like the combinations on *page 73*: the colors are well-balanced; although "skewed" to one side of the color wheel.

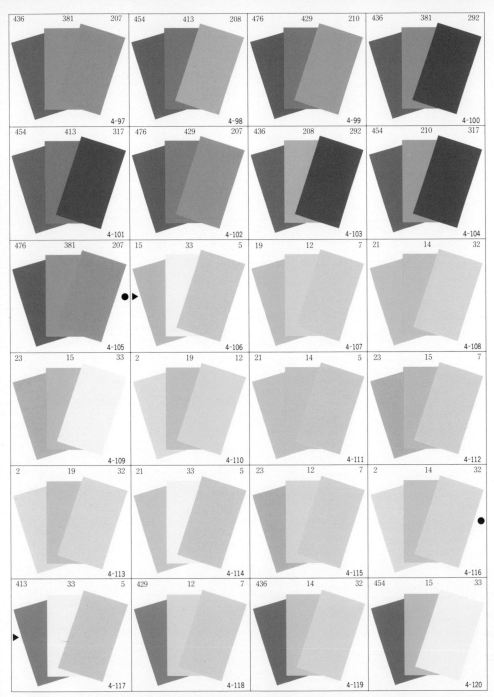

 Here, even more than on *page 73*, we find that combinations of three colors of the same shade — whether vivid, dark, dull, or light — lack contrast and look blurry and unfocused (*4-84* to *4-116*). The complementary colors tend to cancel each other out, emphasizing the third color.



82

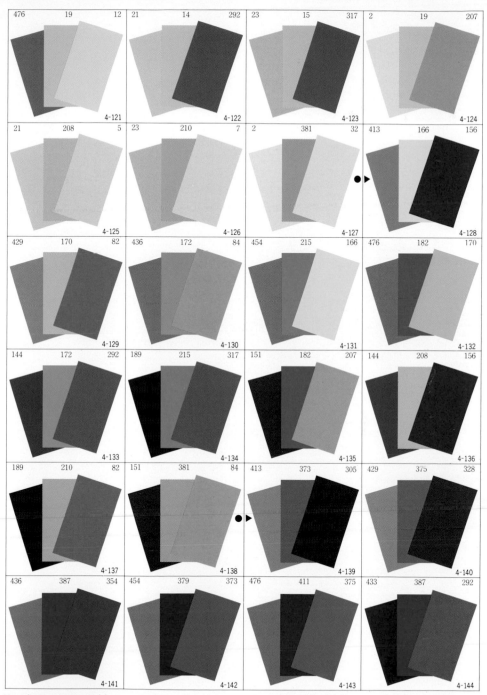

To achieve variety and harmony, it's necessary to change one of the two complementary colors to a lighter or darker shade. This way, the two colors won't negate each other, and will be put on an equal footing with the third color. (Compare *4-73* with *4-128*, which replaces one of the complementary vivid colors with a dull color.)

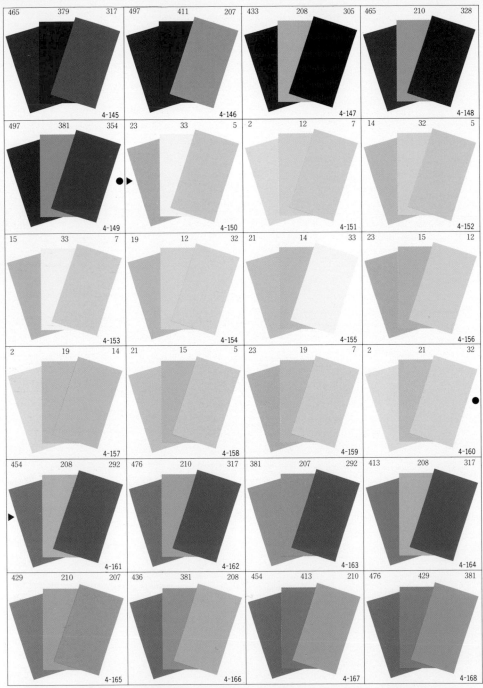

| 465 | 379 | 317 | | 497 | 411 | 207 | | 433 | 208 | 305 | | 465 | 210 | 328 |
| --- | --- | --- | --- | --- | --- | --- | --- | --- | --- | --- | --- | --- | --- |
| | | 4-145 | | | | 4-146 | | | | 4-147 | | | | 4-148 |

| 497 | 381 | 354 | | 23 | 33 | 5 | | 2 | 12 | 7 | | 14 | 32 | 5 |
| --- | --- | --- | --- | --- | --- | --- | --- | --- | --- | --- | --- | --- | --- |
| | | 4-149 | | | | 4-150 | | | | 4-151 | | | | 4-152 |

| 15 | 33 | 7 | | 19 | 12 | 32 | | 21 | 14 | 33 | | 23 | 15 | 12 |
| --- | --- | --- | --- | --- | --- | --- | --- | --- | --- | --- | --- | --- | --- |
| | | 4-153 | | | | 4-154 | | | | 4-155 | | | | 4-156 |

| 2 | 19 | 14 | | 21 | 15 | 5 | | 23 | 19 | 7 | | 2 | 21 | 32 |
| --- | --- | --- | --- | --- | --- | --- | --- | --- | --- | --- | --- | --- | --- |
| | | 4-157 | | | | 4-158 | | | | 4-159 | | | | 4-160 |

| 454 | 208 | 292 | | 476 | 210 | 317 | | 381 | 207 | 292 | | 413 | 208 | 317 |
| --- | --- | --- | --- | --- | --- | --- | --- | --- | --- | --- | --- | --- | --- |
| | | 4-161 | | | | 4-162 | | | | 4-163 | | | | 4-164 |

| 429 | 210 | 207 | | 436 | 381 | 208 | | 454 | 413 | 210 | | 476 | 429 | 381 |
| --- | --- | --- | --- | --- | --- | --- | --- | --- | --- | --- | --- | --- | --- |
| | | 4-165 | | | | 4-166 | | | | 4-167 | | | | 4-168 |

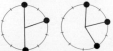

Starting with *4-150*, the hues are more evenly balanced and more skewed to one side of the color wheel — in fact, the hues are almost "equilateral," the third hue falling evenly between the first two. The result: even less contrast (sigh).

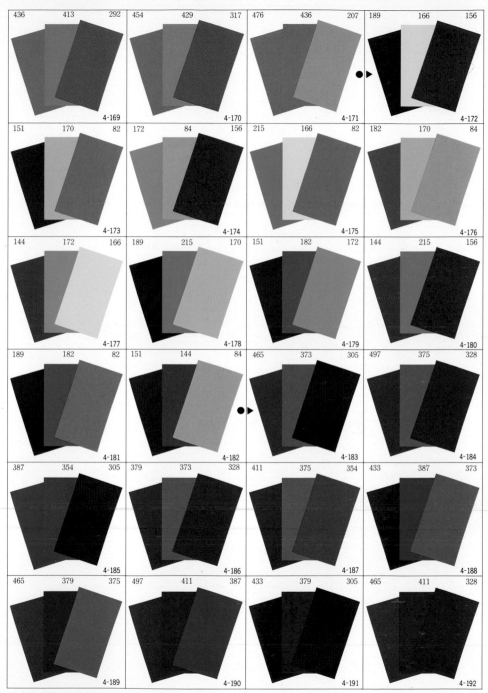

It will come as no surprise that the too-similar hues compete violently (*4-150* to *4-193*), until you change one of the hues to a lighter or darker shade (*4-194* to *4-240*). Paradoxically, combinations of three dark colors (*4-183* to *4-193*) fare somewhat better when there's less contrast between the hues.

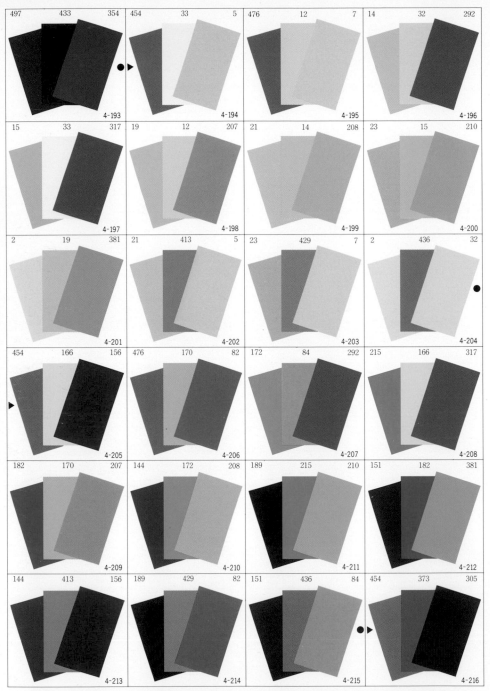

497	433	354	454	33	5	476	12	7	14	32	292
		4-193			4-194			4-195			4-196

15	33	317	19	12	207	21	14	208	23	15	210
		4-197			4-198			4-199			4-200

2	19	381	21	413	5	23	429	7	2	436	32
		4-201			4-202			4-203			4-204

454	166	156	476	170	82	172	84	292	215	166	317
		4-205			4-206			4-207			4-208

182	170	207	144	172	208	189	215	210	151	182	381
		4-209			4-210			4-211			4-212

144	413	156	189	429	82	151	436	84	454	373	305
		4-213			4-214			4-215			4-216

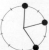

These color combinations with one dull color and two light colors (*4-194* to *4-204*) would be perfect for a contemporary apartment or a summer wardrobe: the three colors clearly belong to the same family, but there's enough variation in hue as well as shade to hold our interest.

86

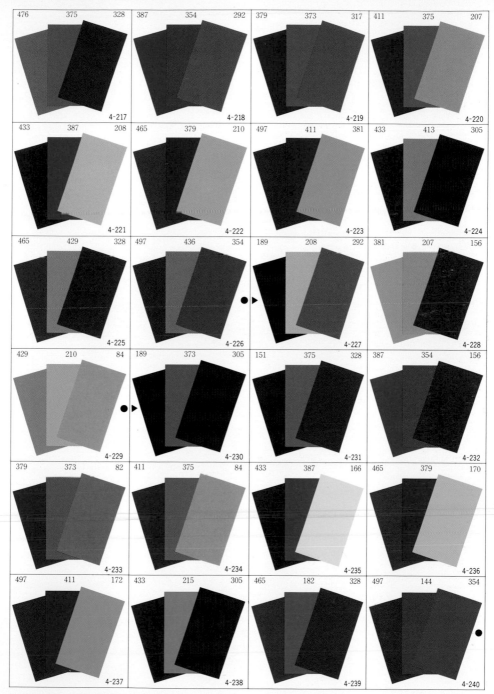

From *4-227* to *4-240*, the color combinations mix one vivid color with two dull colors or two dark colors — a very lively and festive scheme, reminiscent of traditional folk colors. Vivid colors look particularly nice when sandwiched between two dark colors (use the vivid color as the accent color).

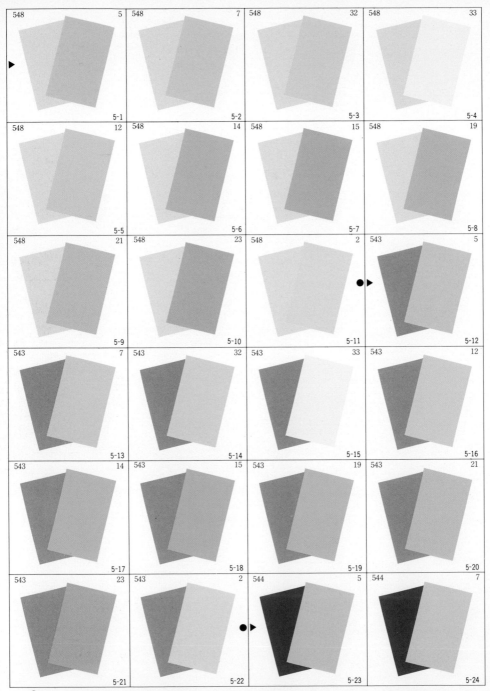

548 — 5	548 — 7	548 — 32	548 — 33
5-1	5-2	5-3	5-4
548 — 12	548 — 14	548 — 15	548 — 19
5-5	5-6	5-7	5-8
548 — 21	548 — 23	548 — 2	543 — 5
5-9	5-10	5-11	5-12
543 — 7	543 — 32	543 — 33	543 — 12
5-13	5-14	5-15	5-16
543 — 14	543 — 15	543 — 19	543 — 21
5-17	5-18	5-19	5-20
543 — 23	543 — 2	544 — 5	544 — 7
5-21	5-22	5-23	5-24

● **Achromatic Hues** Two-color combinations that use black, gray, or white are always harmonious and almost always beautiful. The prism shows us that white light contains all the other colors in the spectrum, so achromatic colors relate equally well to all other hues and shades.

88

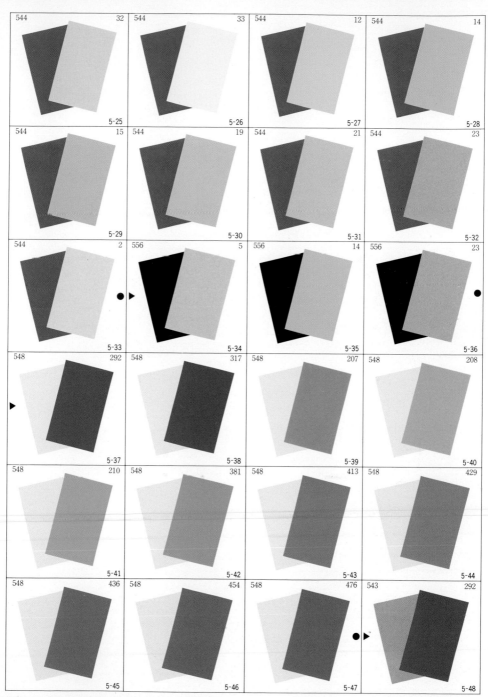

Color combinations using white have not been included here, since you can easily compare the white of the paper with any color. Instead, the four achromatic colors — black (*DIC 556*), dark gray (*DIC 544*), gray (*DIC 543*), and light gray (*DIC 548*) — have been paired with each of the 44 light, dull, vivid, and dark colors.

89

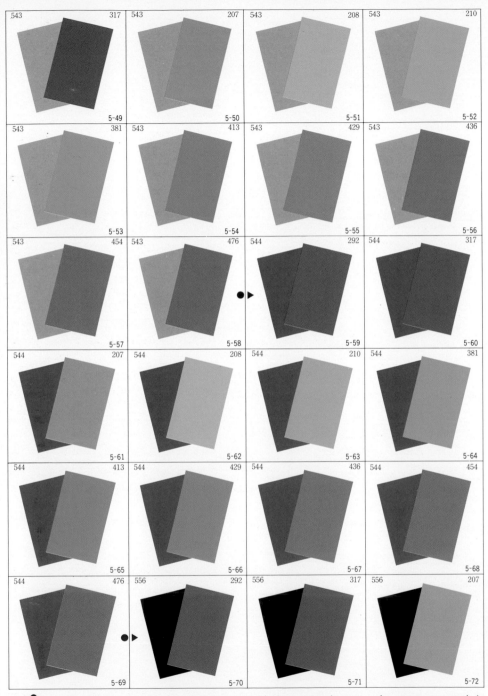

543	317	543	207	543	208	543	210
5-49		5-50		5-51		5-52	

543	381	543	413	543	429	543	436
5-53		5-54		5-55		5-56	

543	454	543	476	544	292	544	317
5-57		5-58		5-59		5-60	

544	207	544	208	544	210	544	381
5-61		5-62		5-63		5-64	

544	413	544	429	544	436	544	454
5-65		5-66		5-67		5-68	

544	476	556	292	556	317	556	207
5-69		5-70		5-71		5-72	

Since hue no longer matters, contrast is crucial when using achromatic colors. As you can see, light colors go best with gray or dark gray, dull colors blend well with dark gray or black, vivid colors look nicest with light gray or black, and dark colors work best with gray or black.

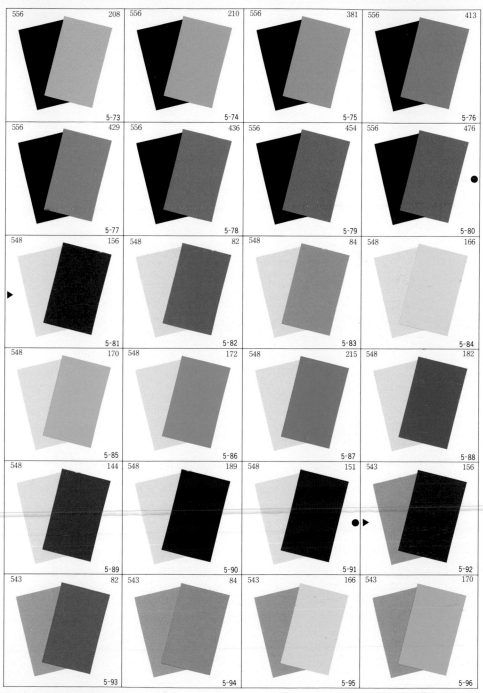

The least effective combinations are light colors with light gray (not enough contrast), light colors with black (too much contrast!), dull colors with gray, the darker vivid colors with dark gray (*5-109* to *5-112*), dark colors with light gray (again, too much contrast), or dark colors with dark gray (too little contrast).

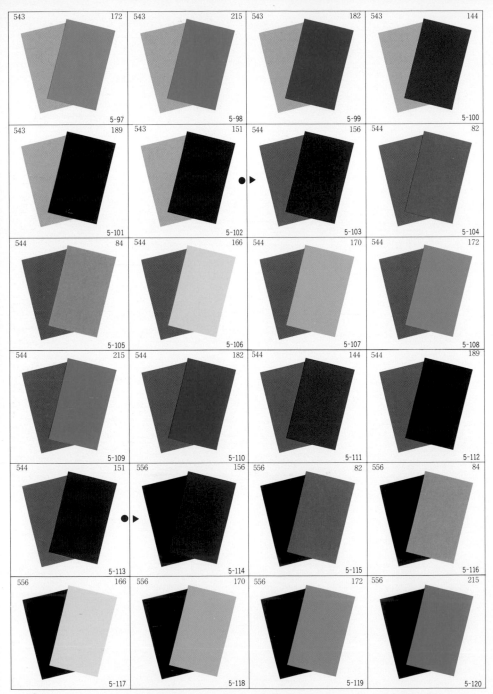

 Since white reflects light more than any other color, it's the brightest and most visible color you can use — that's why you see it so often on book and record jackets (but less often on posters, which are displayed against white walls). White also lends harmony to a clashing color scheme.

92

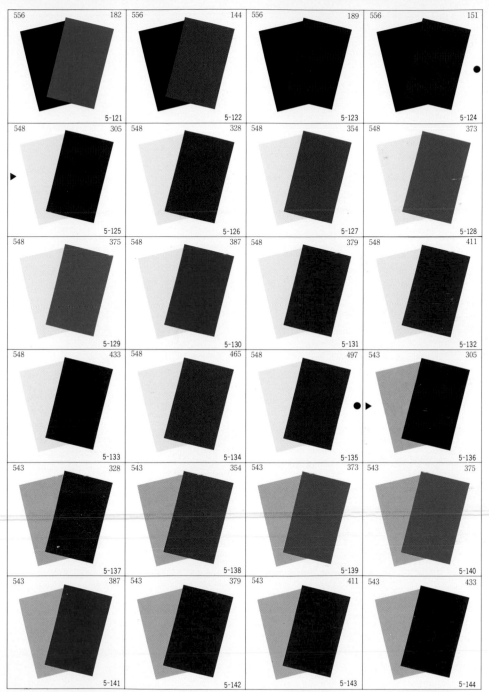

556	182	556	144	556	189	556	151
5-121		5-122		5-123		5-124	
548	305	548	328	548	354	548	373
5-125		5-126		5-127		5-128	
548	375	548	387	548	379	548	411
5-129		5-130		5-131		5-132	
548	433	548	465	548	497	543	305
5-133		5-134		5-135		5-136	
543	328	543	354	543	373	543	375
5-137		5-138		5-139		5-140	
543	387	543	379	543	411	543	433
5-141		5-142		5-143		5-144	

Gray blends well with vivid colors, but not with dull, muddled colors like dark brown or olive green that already contain a lot of gray. In general, gray should be used as the background color, and the other color as the accent; for instance, red type on a gray background works well, but not gray lettering on a red background.

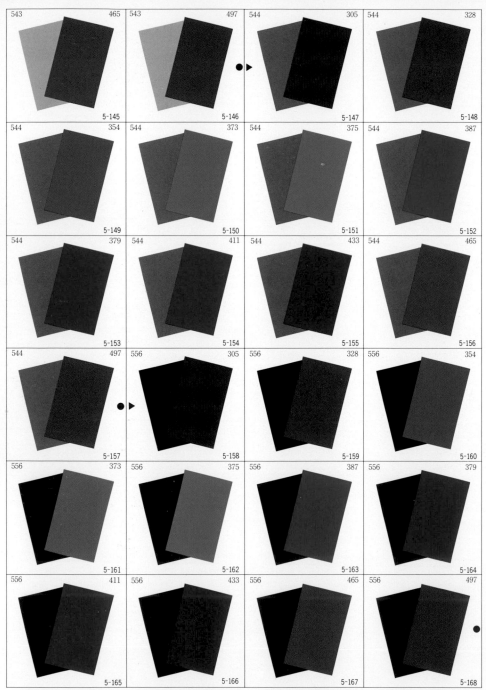

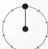 White makes even vivid colors look dull and washed-out, but black enchances colors and makes them look bold and vibrant. The only exceptions are very light colors, which fade into white next to black. If type prints in a pale color against a black background, it will look like white.

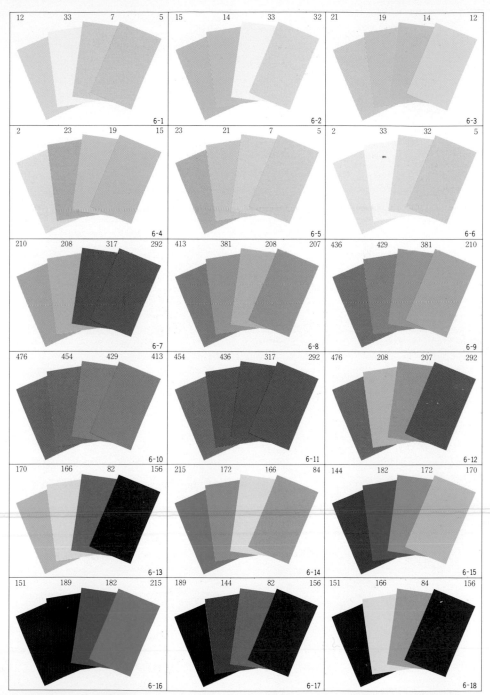

● **Four-Color Combinations** These four-color combinations have been chosen for aesthetic appeal as well as color relationship. Combinations *6-1* to *6-24* resemble the three-color combinations using similar colors (*page 58*), but here there are "gaps" in the sequence when the hues would otherwise be too close.

375	373	328	305		379	387	373	354		433	411	387	375
			6-19					6-20					6-21

497	465	411	379		465	433	328	305		497	373	354	305
			6-22					6-23					6-24

381	208	317	5		429	381	208	32		454	429	381	12
			6-25					6-26					6-27

454	429	15	292		454	21	207	292		2	210	207	292
			6-28					6-29					6-30

387	373	328	156		411	387	373	84		465	411	387	170
			6-31					6-32					6-33

465	411	215	305		465	144	354	305		151	375	354	305
			6-34					6-35					6-36

Beginning with 6-25, one of the four colors in each combination has been lightened or darkened in shade to increase the overall harmony. Combinations with three dark colors and one vivid color (6-31 to 6-36) are particularly crisp and striking, and 6-37 to 6-42, with three dull colors and a light color, look cool and natural.

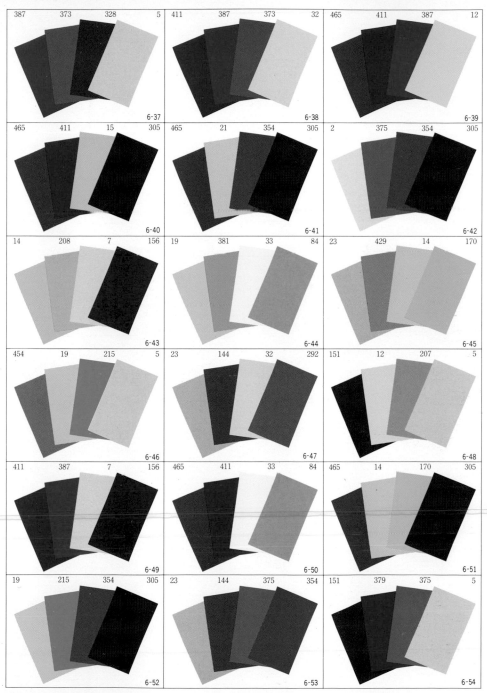

387	373	328	5	411	387	373	32	465	411	387	12
			6-37				6-38				6-39

465	411	15	305	465	21	354	305	2	375	354	305
			6-40				6-41				6-42

14	208	7	156	19	381	33	84	23	429	14	170
			6-43				6-44				6-45

454	19	215	5	23	144	32	292	151	12	207	5
			6-46				6-47				6-48

411	387	7	156	465	411	33	84	465	14	170	305
			6-49				6-50				6-51

19	215	354	305	23	144	375	354	151	379	375	5
			6-52				6-53				6-54

When too many hues and shades are used, the color scheme lacks unity and does not blend. Beginning with 6-43, the combinations use a wide range of hues with three different shades, and the result is a colorful chaos. Combinations 6-49 to 6-54 can be divided into two pairs of related hues for a more harmonious effect.

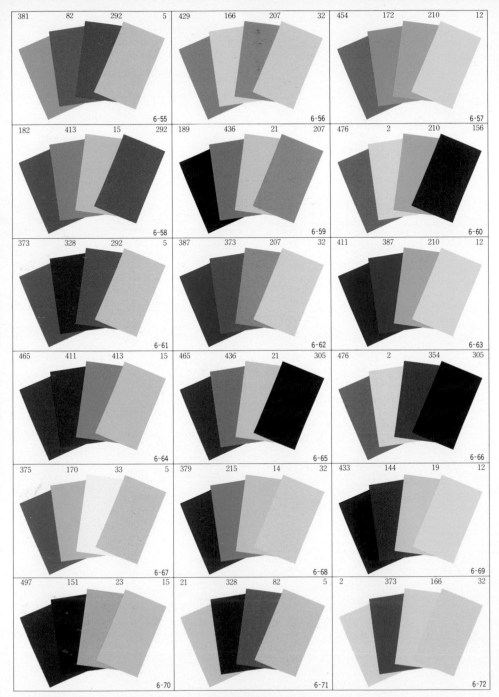

381	82	292	5

6-55

429	166	207	32

6-56

454	172	210	12

6-57

182	413	15	292

6-58

189	436	21	207

6-59

476	2	210	156

6-60

373	328	292	5

6-61

387	373	207	32

6-62

411	387	210	12

6-63

465	411	413	15

6-64

465	436	21	305

6-65

476	2	354	305

6-66

375	170	33	5

6-67

379	215	14	32

6-68

433	144	19	12

6-69

497	151	23	15

6-70

21	328	82	5

6-71

2	373	166	32

6-72

Combinations 6-55 to 6-72 use three colors with related hues and one complementary color, again with three different shades (for instance, 6-55 uses a light color, two dull colors, and a vivid color). The "odd" color emphasizes the differences between the related colors and provides an accent: unity with a sense of rhythm.

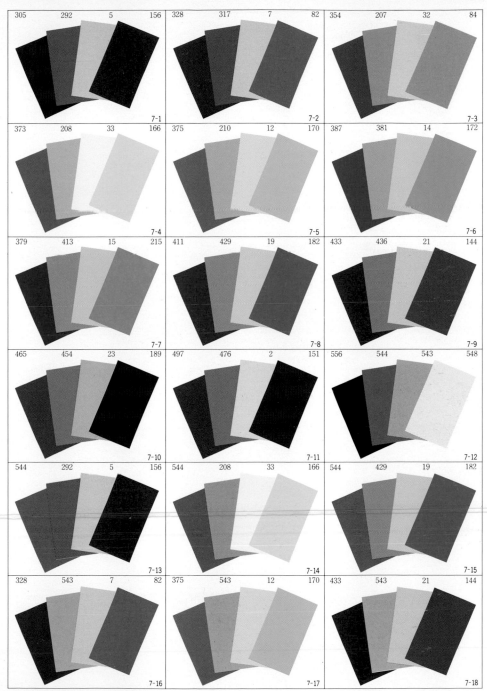

● **Color Progressions** From 7-1 to 7-12, the four-color combinations are simplicity itself: the same hue is presented in four different shades. These combinations resemble the effect of light and shadow on color, and 7-13 to 7-24 take this even further by using black or gray as one of the colors (*see also pages 88-94*).

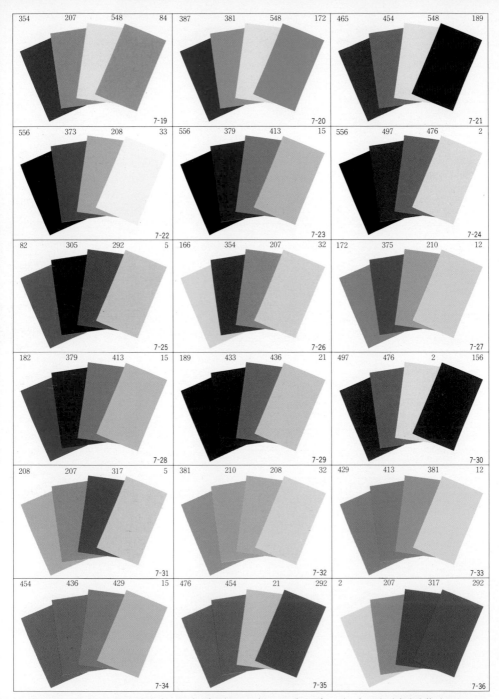

Combinations 7-25 to 7-30 shift the vivid color by one hue on the color wheel, with delightfully harmonious results. But 7-31 to 7-36 (which use three similar dull colors with a related light color) and 7-37 to 7-42 (three dark colors with a vivid color) don't show enough contrast between the three subordinate colors.

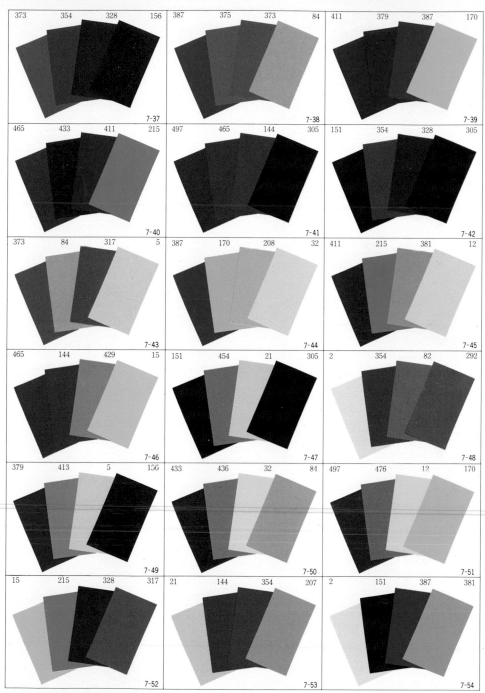

373	354	328	156		387	375	373	84		411	379	387	170
			7-37					7-38					7-39

465	433	411	215		497	465	144	305		151	354	328	305
			7-40					7-41					7-42

373	84	317	5		387	170	208	32		411	215	381	12
			7-43					7-44					7-45

465	144	429	15		151	454	21	305		2	354	82	292
			7-46					7-47					7-48

379	413	5	156		433	436	32	81		497	476	12	170
			7-49					7-50					7-51

15	215	328	317		21	144	354	207		2	151	387	381
			7-52					7-53					7-54

Finally, combinations 7-43 to 7-54 use four different shades, but with a new twist. Combinations 7-43 to 7-48 cut diagonally across hue as well as shade (try matching up the *DIC* numbers with the basic color chart), and 7-49 to 7-54 each use two different shades of two different hues for a "contrasting pairs" effect.

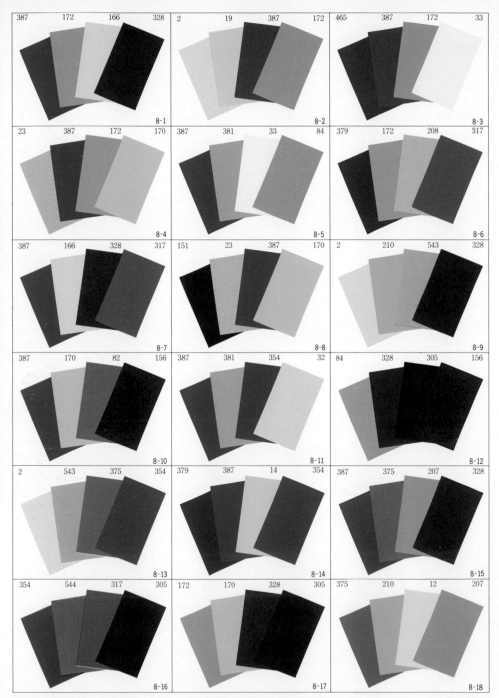

8-1	8-2	8-3
387 172 166 328	2 19 387 172	465 387 172 33

8-4	8-5	8-6
23 387 172 170	387 381 33 84	379 172 208 317

8-7	8-8	8-9
387 166 328 317	151 23 387 170	2 210 543 328

8-10	8-11	8-12
387 170 82 156	387 381 354 32	84 328 305 156

8-13	8-14	8-15
2 543 375 354	379 387 14 354	387 375 207 328

8-16	8-17	8-18
354 544 317 305	172 170 328 305	375 210 12 207

● **Natural Colors** The color combinations on these pages use elements from nature: flowers, birds, the sea, and the sky. Natural color schemes look comfortable and familiar to us, and are excellent examples of color harmony. Combinations *8-1* to *8-12* are taken from plants, and *8-13* to *8-24* are inspired by trees.

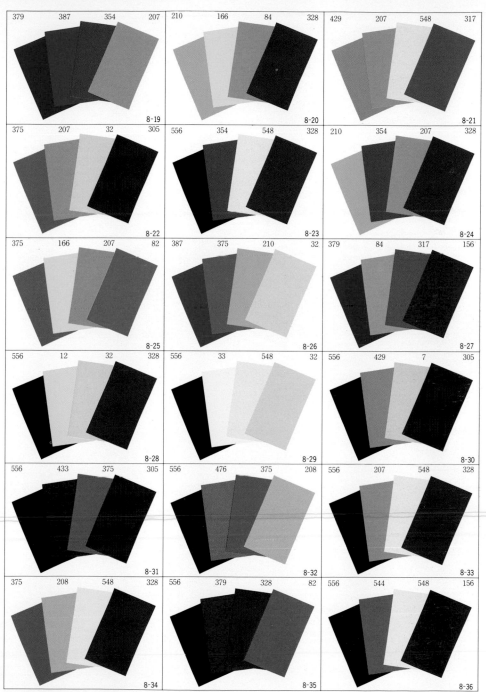

379 387 354 207	210 166 84 328	429 207 548 317	
8-19	8-20	8-21	
375 207 32 305	556 354 548 328	210 354 207 328	
8-22	8-23	8-24	
375 166 207 82	387 375 210 32	379 84 317 156	
8-25	8-26	8-27	
556 12 32 328	556 33 548 32	556 429 7 305	
8-28	8-29	8-30	
556 433 375 305	556 476 375 208	556 207 548 328	
8-31	8-32	8-33	
375 208 548 328	556 379 328 82	556 544 548 156	
8-34	8-35	8-36	

Combinations *8-25* to *8-27* come from vegetables, *8-28* to *8-30* are the colors of butterflies, and *8-31* to *8-39* are the colors of birds. Some birds have very chic color schemes: their built-in "accent colors" (like the red crest of woodpeckers) help females of the species find the right mate.

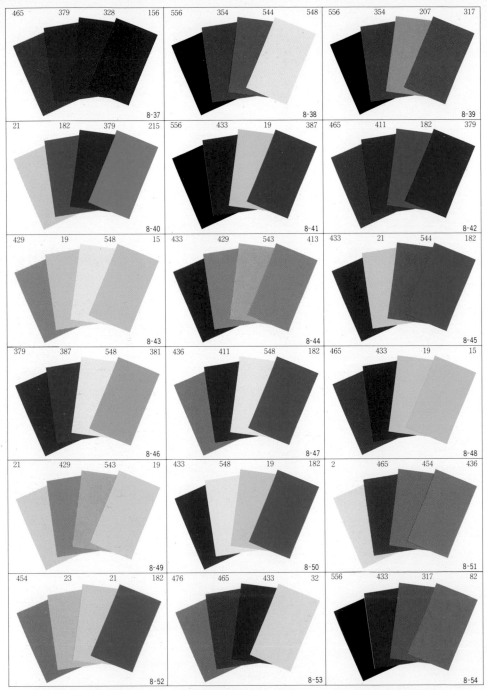

465	379	328	156	556	354	544	548	556	354	207	317

8-37 8-38 8-39

21	182	379	215	556	433	19	387	465	411	182	379

8-40 8-41 8-42

429	19	548	15	433	429	543	413	433	21	544	182

8-43 8-44 8-45

379	387	548	381	436	411	548	182	465	433	19	15

8-46 8-47 8-48

21	429	543	19	433	548	19	182	2	465	454	436

8-49 8-50 8-51

454	23	21	182	476	465	433	32	556	433	317	82

8-52 8-53 8-54

Combinations *8-40* to *8-48* are the colors of the sea, which change according to the weather and the season. Since these colors are cool and not too vivid, they would look fine on a large scale — say, a poster or a billboard. *8-49* to *8-54* are the colors of the sky; the sunset colors (*8-53* and *8-54*) are especially beautiful.

104

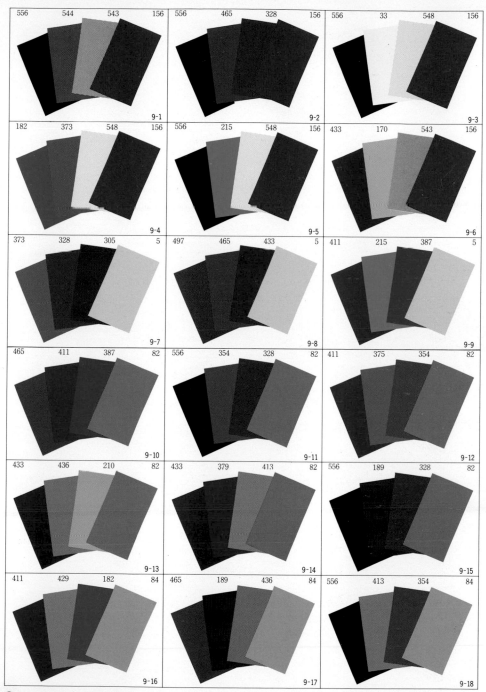

● Contrasting Colors Visibility is one of the keys to a good color scheme, and in these combinations, the dominant color (*right*) is clearly delineated from the three subordinate colors. Using the dominant color as the type color, these combinations might be suitable for billboards, signs, posters, flyers, or book covers.

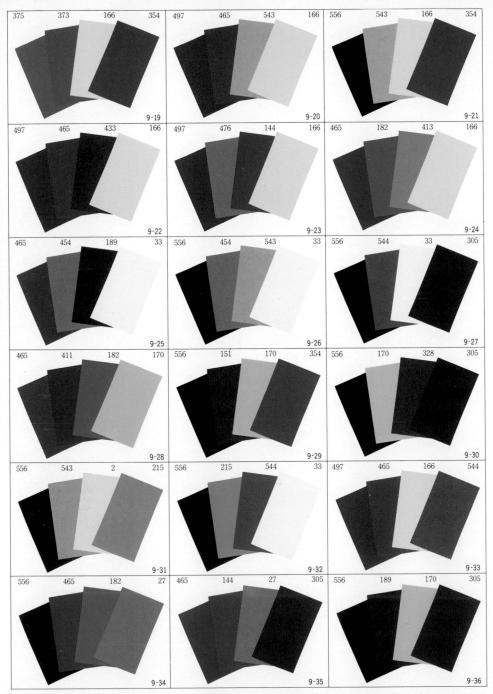

Color schemes with constrasting hues don't have to bring tears to the eye. When the hues in a color combination clash — like purple and cream (9-25), red-violet and yellow-green (9-29), blue and pink (9-34), or purple and yellow-green (9-36) — you can get them to blend by adding achromatic colors and shades of dark brown.

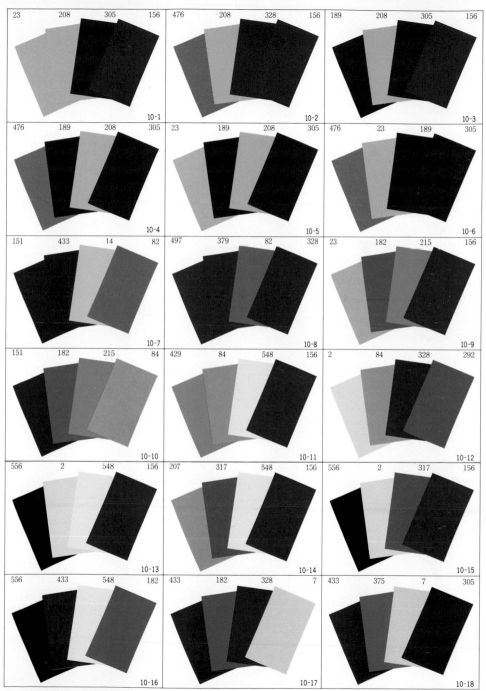

● **Japanese Colors** In Japan, color combinations are often associated with very specific purposes. For instance, combinations *10-1* to *10-6* are taken from *kabuki* theater, *10-7* to *10-12* come from traditional Japanese dress, *10-13* to *10-15* from wedding decorations, and *10-16* to *10-18* are from Japanese textiles.

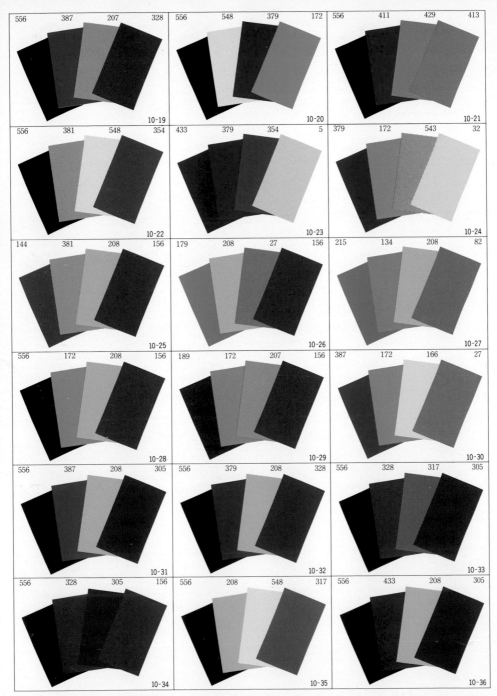

556	387	207	328

10-19

| 556 | 548 | 379 | 172 |

10-20

| 556 | 411 | 429 | 413 |

10-21

| 556 | 381 | 548 | 354 |

10-22

| 433 | 379 | 354 | 5 |

10-23

| 379 | 172 | 543 | 32 |

10-24

| 144 | 381 | 208 | 156 |

10-25

| 179 | 208 | 27 | 156 |

10-26

| 215 | 134 | 208 | 82 |

10-27

| 556 | 172 | 208 | 156 |

10-28

| 189 | 172 | 207 | 156 |

10-29

| 387 | 172 | 166 | 27 |

10-30

| 556 | 387 | 208 | 305 |

10-31

| 556 | 379 | 208 | 328 |

10-32

| 556 | 328 | 317 | 305 |

10-33

| 556 | 328 | 305 | 156 |

10-34

| 556 | 208 | 548 | 317 |

10-35

| 556 | 433 | 208 | 305 |

10-36

Combinations *10-19* to *10-24* are taken from Japanese gardens, *10-25* to *10-27* are from *chiyogami* (paper in colorful patterns), *10-28* comes from a Japanese top, *10-29* from dolls, *10-30* from a traditional handball, and *10-31* to *10-36* are from lacquerwork. Red is often used as an accent color in Japanese toys and folk art.

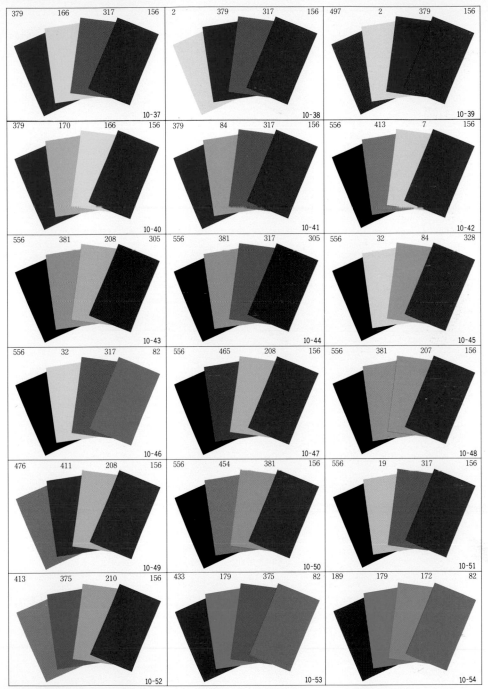

Combinations *10-37* to *10-42* and *10-49* to *10-51* are taken from Japanese playing cards, *10-43* to *10-48* are from Japanese paintings, and *10-52* to *10-54* are from fishing banners. Many typically Japanese color schemes use pale and dark shades of green and brown, and vivid red or orange as the accent.

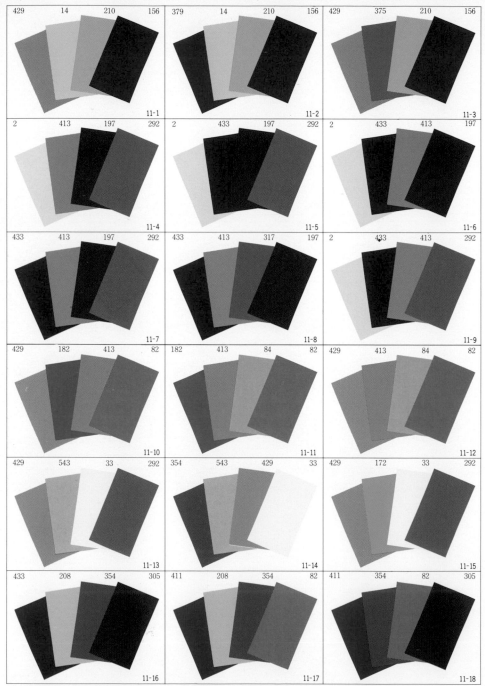

● **National Colors** Inspiring color schemes can be found in almost any culture. Combinations *11-1* to *11-3* are taken from Chinese porcelain, *11-4* to *11-9* come from Indian prints, *11-10* to *11-12* from Persian miniatures, *11-13* to *11-15* from Ancient Egyptian paintings, and *11-16* to *11-18* are from Incan textiles.

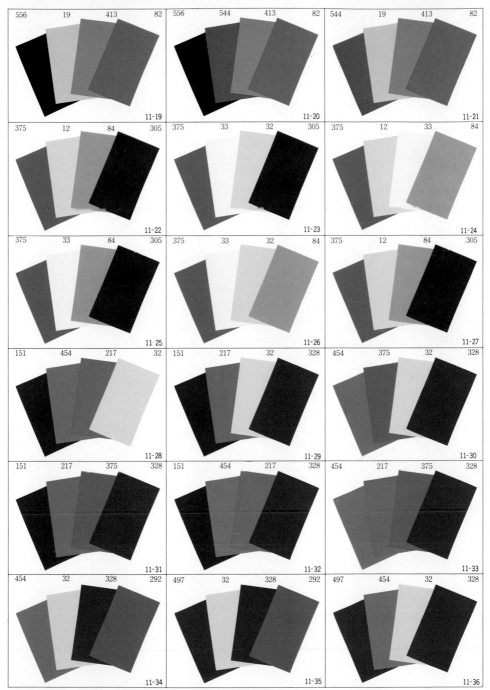

Combinations *11-19* to *11-21* come from African masks, *11-22* to *11-27* from the interiors of early American homes (such as the Pennsylvania Dutch), *11-28* to *11-33* from Victorian interiors, and *11-34* to *11-39* are from Ancient Greek pottery (which used purple and dark brown pigments with the natural clay).

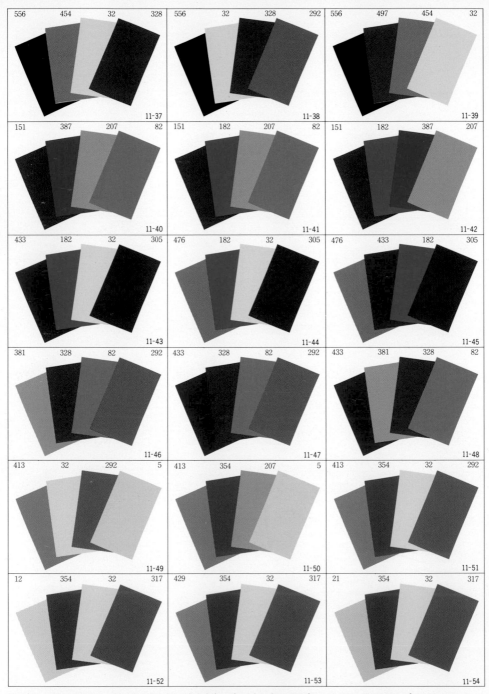

Combinations *11-40* to *11-42* come from brightly-colored Indian textiles, *11-43* to *11-45* are from Persian rugs, *11-46* to *11-48* from Egyptian Coptic textiles, *11-49* to *11-51* from French Gobelin tapestries, and *11-52* to *11-63* are from British Wedgewood porcelain (white designs against a pale blue background).

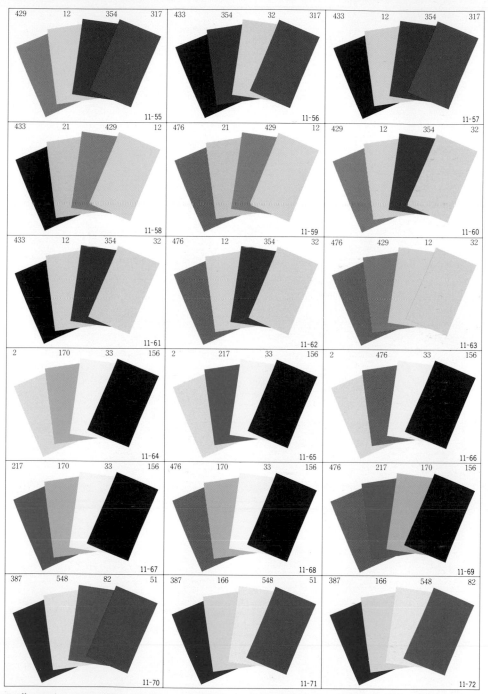

429	12	354	317
			11-55

433	354	32	317
			11-56

433	12	354	317
			11-57

433	21	429	12
			11-58

476	21	429	12
			11-59

429	12	354	32
			11-60

433	12	354	32
			11-61

476	12	354	32
			11-62

476	429	12	32
			11-63

2	170	33	156
			11-64

2	217	33	156
			11-65

2	476	33	156
			11-66

217	170	33	156
			11-67

476	170	33	156
			11-68

476	217	170	156
			11-69

387	548	82	51
			11-70

387	166	548	51
			11-71

387	166	548	82
			11-72

Finally, combinations *11-64* to *11-69* are *art nouveau* colors, popular at the turn of the century: lavender, pink, red, blue-green, yellow-green, and pale yellow. *11-70* to *11-72* are typical *art deco* colors, taken from the Paris Exposition of 1925. Modern *art deco* schemes use soft, pastel shades of pink, green, and blue.

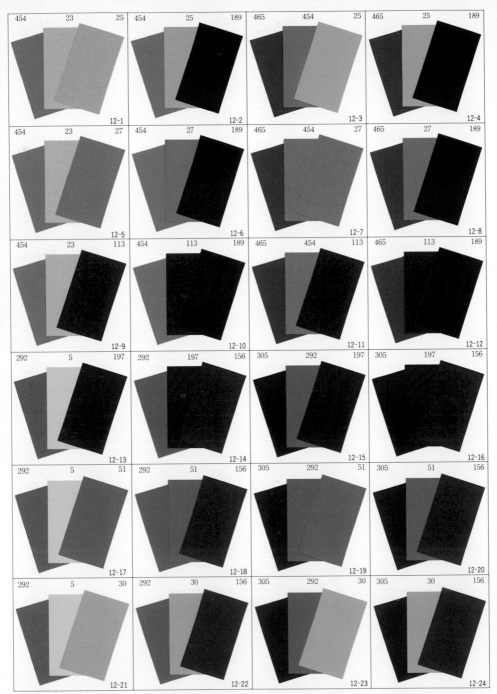

454	23	25	454	25	189	465	454	25	465	25	189
		12-1			12-2			12-3			12-4
454	23	27	454	27	189	465	454	27	465	27	189
		12-5			12-6			12-7			12-8
454	23	113	454	113	189	465	454	113	465	113	189
		12-9			12-10			12-11			12-12
292	5	197	292	197	156	305	292	197	305	197	156
		12-13			12-14			12-15			12-16
292	5	51	292	51	156	305	292	51	305	51	156
		12-17			12-18			12-19			12-20
292	5	30	292	30	156	305	292	30	305	30	156
		12-21			12-22			12-23			12-24

● **Pink and Blue** If you've been watching television lately, you know that pink and blue are "hot" colors, although it takes quite a bit of finesse to use them properly. Combinations *12-1* to *12-24* show the two sides of pink: the cooler, purplish side (*12-1* to *12-12*), and the warmer, yellowish hues (*12-13* to *12-24*).

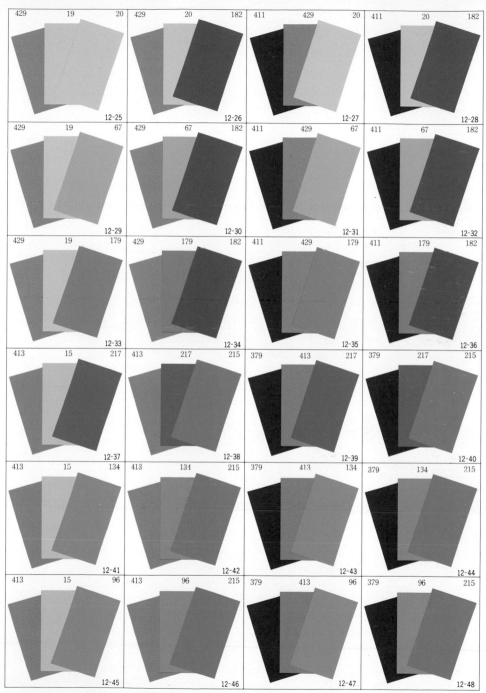

Even blue has a warm and a cool side. The grayish hues of blue (*12-25* to *12-36*) are distinctly cold, but when you add a tint of yellow, the resulting greenish hues (*12-37* to *12-48*) are surprisingly warm. But no matter how warm it looks, don't mix blue-green with warm colors like red or yellow — it will clash horribly.

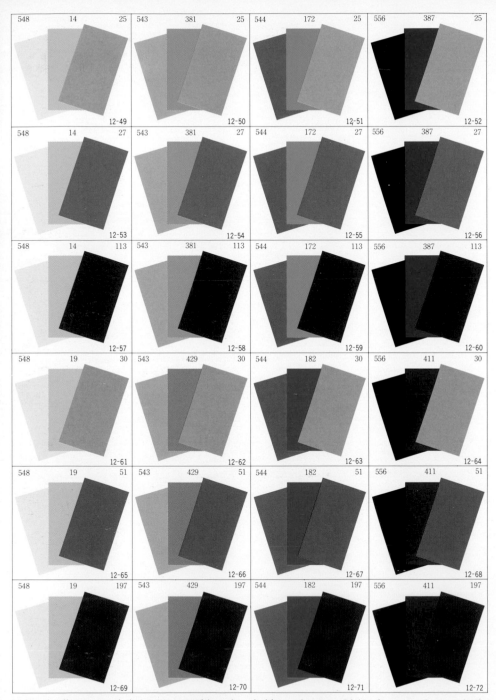

Pink and yellow-green clash (*12-49* to *12-60*), and so do blue and orange-red (*12-61* to *12-72*), since they're too far apart on the color wheel to have any elements in common, and too close to be complementary. To make these combinations work, add an achromatic color like black or gray. Achromatic colors make great mediators.

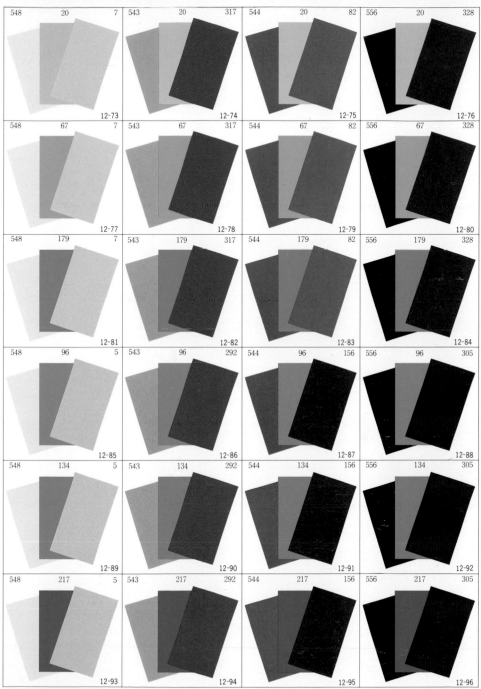

In general, primary colors like red and blue are easier to blend than secondary colors like red-orange and blue-green, and light shades of pink and blue blend better than darker shades. The color combinations at the top of the page (which use light shades of blue) and the ones at left (which use light shades of pink) are in harmony.

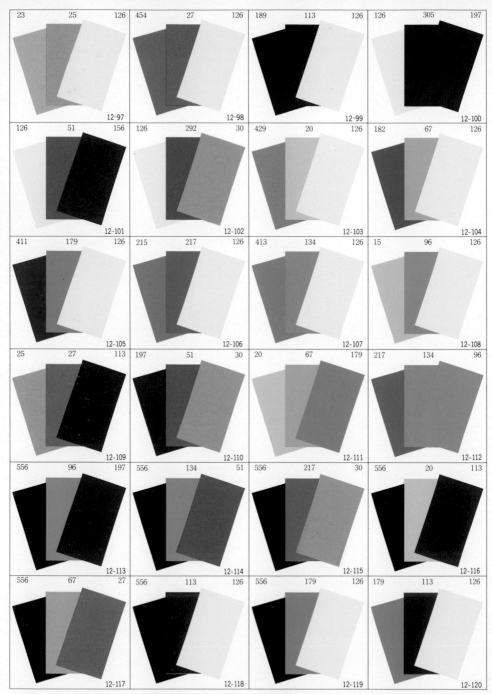

The three process colors — magenta, yellow, and cyan — create a mixed impression. On the one hand, they look fresh and unusual (as we can see on *pages 42-43*), but on the other hand they look cheap and artificial, almost like a printing error. Black, the fourth process color, can mellow them out a little (*12-113* to *12-119*).

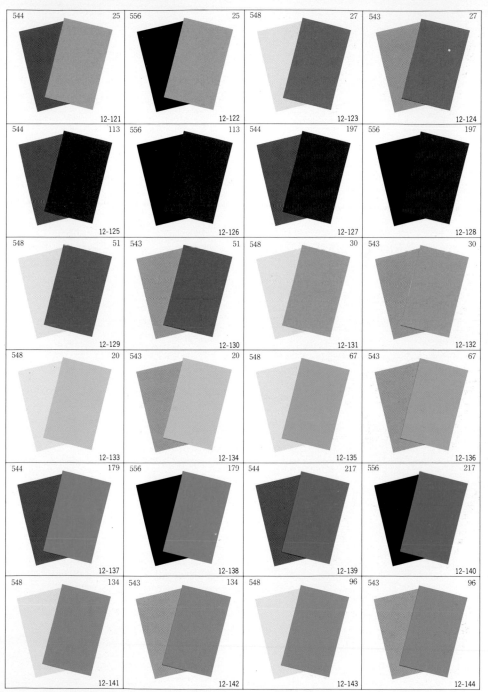

Pink and blue both blend well with achromatic colors: the combination looks contemporary, urban, and relaxed (almost to the point of catatonia in some cases), qualities much sought after when designing clothes or packaging for the young. Pink and gray is currently in vogue for women's clothing and office interiors.

122-137　Practical Applications

Color combinations do not exist in a vacuum — ultimately, they must be used in the real world, whether on a poster, a scarf, or a blender. In this section, we present a few examples of color harmony drawn from real life: not only paintings and graphic design, but interior design, textiles, folk art, and household appliances. The color relationships that we see in these everyday objects can be applied equally well to graphic design; for instance, if a color combination looks nice on the walls of your apartment, it will probably look nice on your next book cover as well.

138-141　Choosing Colors

Here we've presented our 12 useful guidelines for selecting your own color combinations. We've already touched on many of these points in the captions to the color combinations on *pages 46-119* — for instance, the importance of using contrasting shades, and the ability of achromatic colors to blend with almost every other color. It's a good idea to apply these guidelines to every color scheme that you use . . . particularly those color schemes that come to you in a flash of inspiration. Is there enough variation in the shades? Is it original? And most important of all, is it right for your purpose?

142　Color Conversion Chart

All of the 61 basic colors can be simulated with the four process ink colors — yellow, magenta, cyan, and black. This color conversion chart tells you what percentage of each process color to use; for instance, to simulate red (*DIC 156*) with four-color printing, use 100% yellow plus 100% magenta. (Keep in mind that these percentages are approximate.) Here's a general rule: the percentages of all four process colors shouldn't add up to more than 200%, or the color will appear dark and muddy.

143-158　Color Cards

The 61 color cards — one for each of the basic colors — can help you choose your color combinations, and also show you what the colors will look like on a larger scale. Cut out the masks on the book jacket flaps to "isolate" individual colors and see how they'll look against a white or a black background. You can also cut out the individual color cards and use them as a "color deck" — simply punch two holes in the left edge of each card, and use two binder rings (available at any stationery store) to keep them all together.

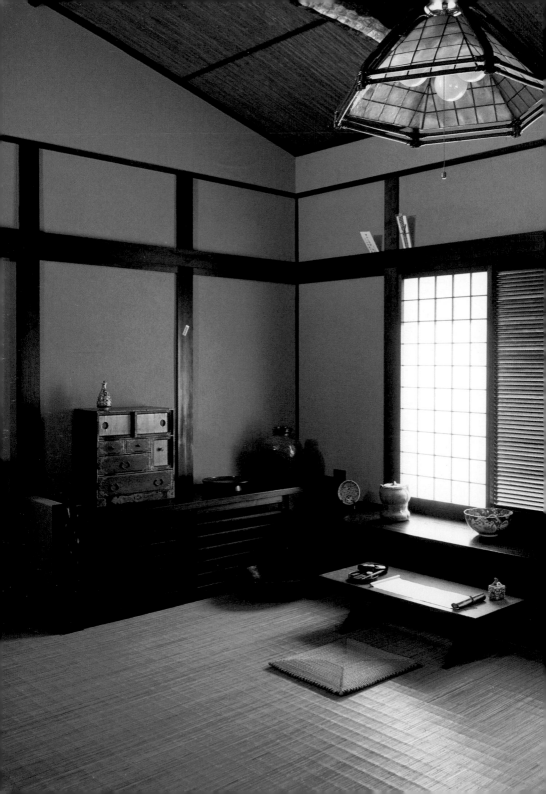

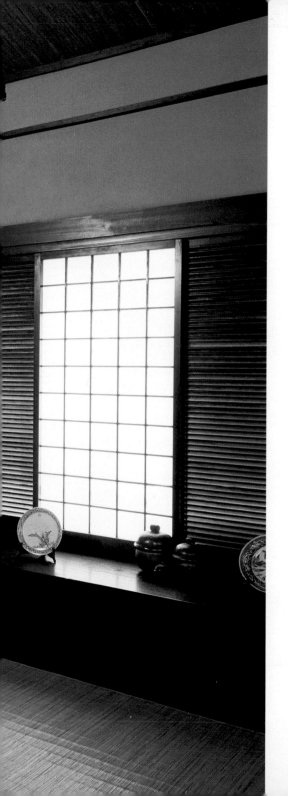

Japanese Interiors

This Japanese country-style room is an excellent example of similar hues (*see page 51*) that vary considerably in shade. The pillars, beams, latticework, and shelves have all been painted an earthy dark brown (*DIC 305*), which contrasts with the amber walls (*DIC 317*) and the white rice-paper windows, creating an effect that's formal and old-fashioned but also very unified. Reeds and cedar planks have been used in the ceiling, and the floor is covered with bamboo mats (*DIC 32*).

To Western tastes, this room may look somber and lacking in color, but the effect is really much more subtle than meets the eye. Brown is a very complex color — much more complex than, say, blue or yellow, since it's a combination of all three primary colors — and the range of contrast here is much greater than you're likely to see in Western-style interiors. The blue-and-white plates provide a nice accent.

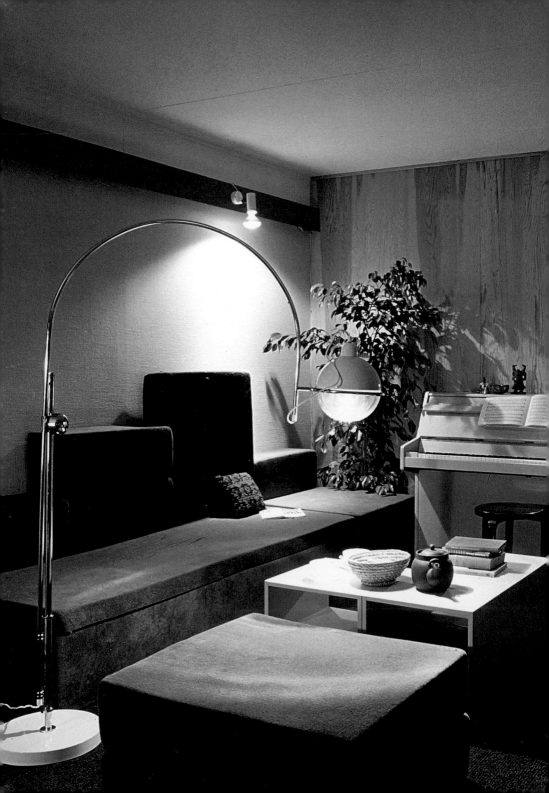

Western Interiors

Unlike the natural daylight in the Japanese room on *pages 122-123*, the light in this Western-style living room comes from lamps and track lighting, which allows for a somewhat bolder color scheme. In this room, the ceiling and the wall behind the couch both match the beige color of the piano, lamp, and modular table (*DIC 7*), while the blond wood of the partition wall and the burnt orange of the carpet (*DIC 82*) are simply darker shades of the same hue. On the other hand, the blue sofa and settee (*DIC 182*) are almost exactly complementary to the carpet (*see page 78*), for an effect that is both dramatic and harmonious (and surprisingly warm, even though blue is a cool color). To add a little extra flair to the room, the red lighting track and bar stool (*DIC 156*) use a hue that is similar to the orange carpet, and the green plant and books use a hue that is similar to the blue furniture.

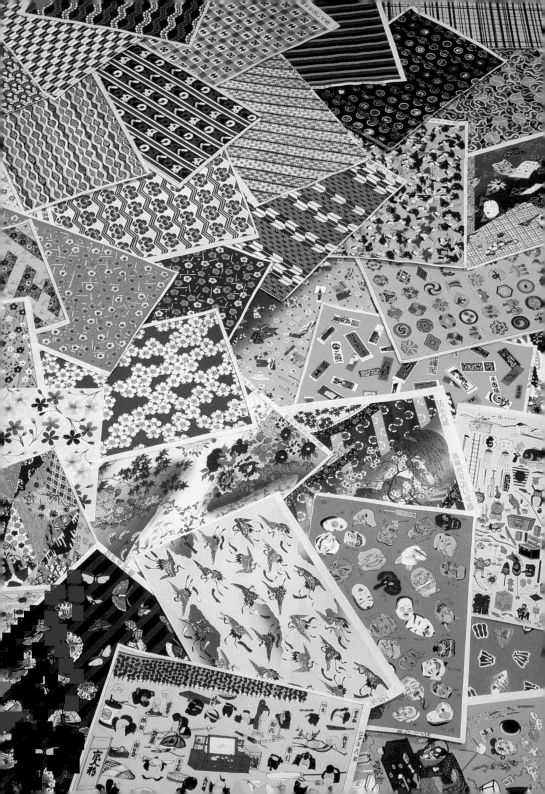

Patterns

These Japanese colored paper designs (*left*) are called *chiyogami*, and range from abstract stripes and checks to more recognizably floral patterns and realistic representations of masks, birds, and butterflies. The hues are bright and contrasting, sometimes even clashing (yellow-green, red, and purple stripes!), but not only is the overall effect harmonious, any small portion of the paper is also harmonious by itself.

Western textiles (*top right*) tend to use pastels and quiet earth colors more than their Japanese counterparts: contrasting hues are considered too loud, the one exception perhaps being men's ties. Even rainbow designs like the dish towels (*left*) appear dull and muted, since the bright colors are mitigated by stripes of white. The colorful patterns suggested by French provincial designs (*top right*) or Indian fabrics (*bottom*) are a little more lively.

Tradtional Japanese textiles (*bottom right*) use design elements similar to those in *chiyogami* — uneven stripes and checks, elaborate paisley-like filigree, and floral motifs — but the colors come from natural dies, and the effect is somewhat more dignified and subdued. Dark blue (*DIC 433*) and white is a color scheme that looks both old-fashioned and highly refined: the kind of colors you would find in a French kitchen.

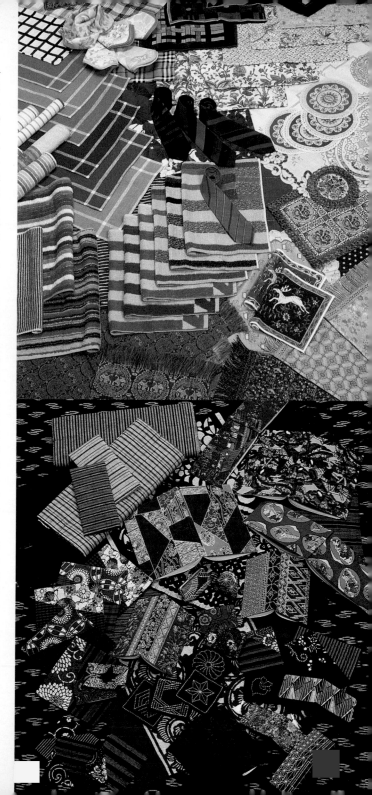

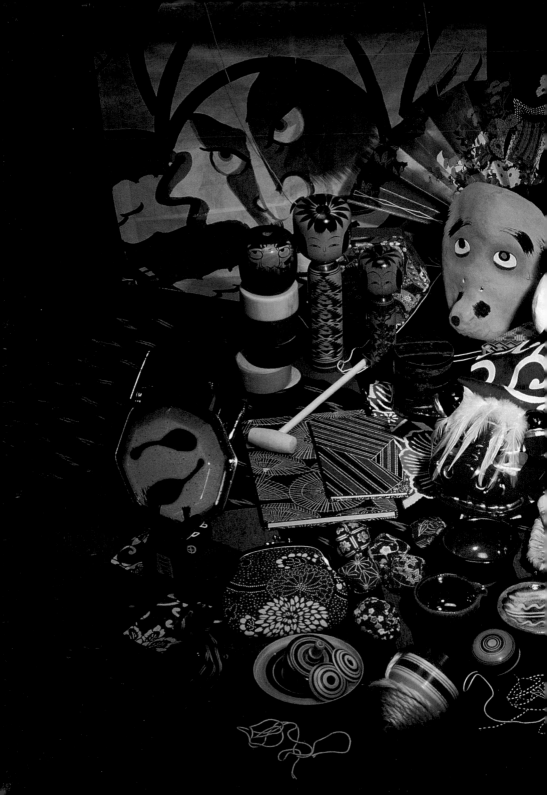

Folk Art

These are the kind of folk art objects and souvenirs that you're likely to see in any Japanese home: kites, fans, wooden dolls, tops, and masks painted in bright, vivid colors. Traditional Japanese paintings and woodblock prints use strong outlines to separate the bright colors, and in almost all of these objects, black, white, or gold has been used to mediate between the vivid hues.

In the tops, the bright color rings are separated by bands of white, and even the colors on the kite (*top*) are divided by black outlines. The fan and the lion's head (*center*) use gold to mediate between the other colors, and the purses and notebooks use white for the same purpose. Many of these folk art objects use the same dark shades of blue, red, and brown that we saw in traditional Japanese textiles (*pages 130-131*).

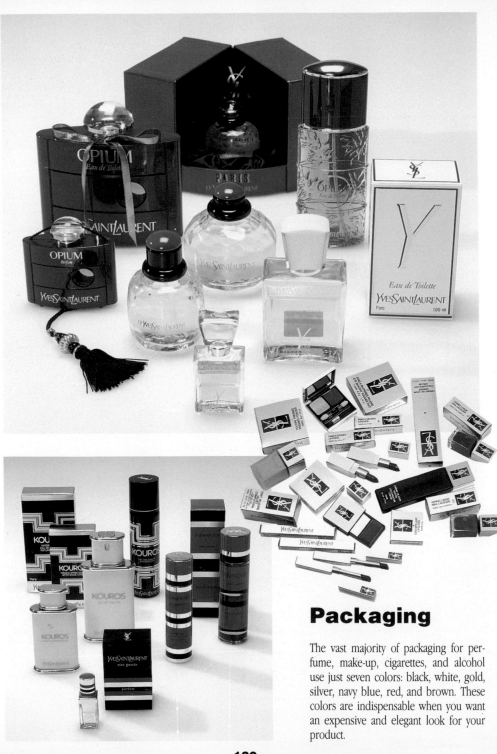

Packaging

The vast majority of packaging for perfume, make-up, cigarettes, and alcohol use just seven colors: black, white, gold, silver, navy blue, red, and brown. These colors are indispensable when you want an expensive and elegant look for your product.

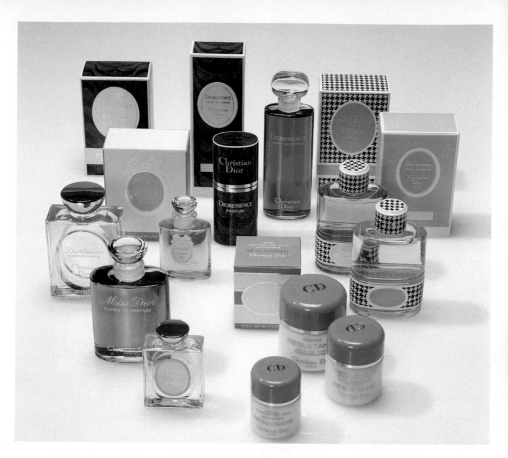

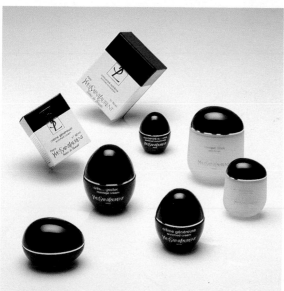

Many of these packages use two-color schemes, often reversing the colors for the sake of variety. Brown and gold, red and black, or white and gold (*top left*) look warm and sumptuous, while black and silver or blue and silver (*far left*) look cool and sophisticated. Gold with brown and black (*center*) looks urbane and elegant without appearing cold.

Although pink (*above*) is warm and accessible, it lacks refinement, and slate blue looks cold and uninviting. Finally, black and white or black and gold (*left*) can make almost any product look expensive.

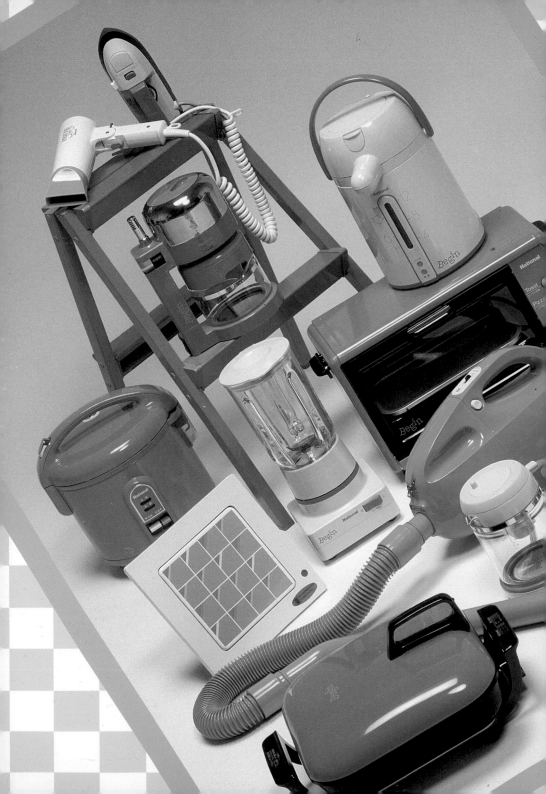

Appliances

Until the late 1960s, household appliances like refrigerators, vacuum cleaners, and blenders were found in just one or two colors: white, and perhaps avocado green or harvest gold. In recent years, manufacturers have caught onto the idea of color-coordinated kitchens and bathrooms, even to the extent of inventing new colors like "platinum" and "toast." These appliances in shades of pink, purple, blue-green, and ocher look cool and sassy; very few people would buy more than one or two of them, which is just as well since these colors work best as accents.

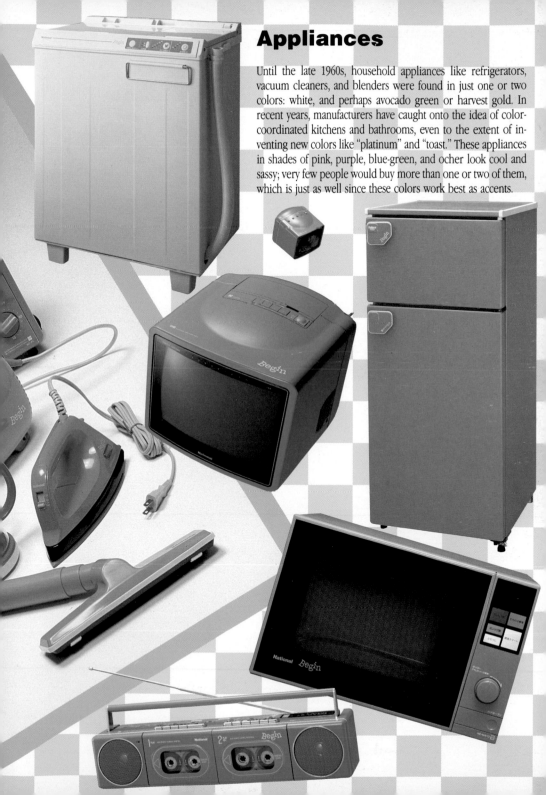

amnesty
international

Posters

In this poster by Ikko Tanaka, the complementary hues of red (*DIC 156*) and green (*DIC 215*) almost cause a strobe effect where they meet. But the thin black lines keep them under control, and the white and black areas provide just enough relief.

In this poster, Keiten Nagatomo also used complementary hues: two shades of blue-violet for the big star (*DIC 21* and *DIC 436*), and two shades of yellow (*DIC 166*) for the small star. His choice of colors shows great care and subtlety, particularly the netural shades of gray (*DIC 544*) and brown (*DIC 354*) for the background.

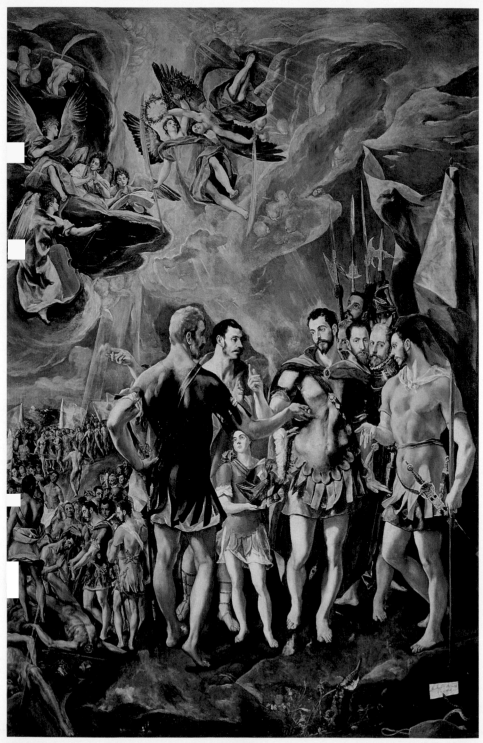

Paintings

Although we tend to imagine painters as dabbing on colors whenever they feel like it, almost all of the great painters from Medieval times to the present were careful to follow the rules of color harmony. El Greco's *The Martyrdom of Saint Mauritius* (1580-1584) demonstrates some of the underlying complexities of the artist's palette: if this painting were placed on a wheel and spun fast enough, the colors would probably blend into gray. Since the color wheel also becomes gray when it's spun fast enough, this tells us that the colors in the painting are almost perfectly balanced.

In the painting, Saint Mauritius is wearing a blue-gray breastplate with a bright red skirt and a green-and-yellow cloak — almost a textbook of contrasting hues and shades in itself, which clearly sets him apart from the other figures in the painting. He is flanked by two other figures wearing complementary colors: a blond-haired figure wearing a dark blue tunic (*DIC 433*) with a pale yellow skirt (*DIC 33*), and a dark-haired figure wearing a yellow tunic with a blue skirt. Even the red-orange banner (*DIC 82*) is complementary to the blue-gray sky (*DIC 429*).

Choosing Colors

1 Know your colors.

Before you even think about which colors to use, you should be familiar with the topics covered on *pages 6-25* of this book: the three characteristics of color (hue, lightness, and saturation), the uses and emotions associated with each color, and the six broad categories of colors (warm, cool, light, dark, vivid, and dull).

It may help to think of a three-dimensional color wheel similar to the one on *page 10*, with the ten vivid colors on the rim of the wheel. As you move toward the center of the wheel, the saturation decreases and the amount of gray in each color increases, so the dull colors would be about halfway to the center of the wheel and gray would be in the very center. As you move up along the vertical axis, the shades become lighter: the light colors are about halfway up the axis, and white is at the very top. When you move down the axis, the shades become darker: the dark colors are about halfway down and black is at the bottom.

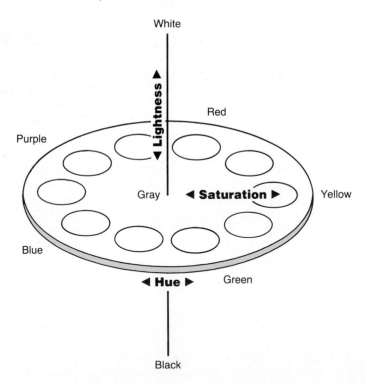

You should know where colors fall on this three-dimensional color wheel in terms of hue, lightness, and saturation. When you combine two or more colors, make sure that there's a reasonable interval between them on the wheel; for instance, if the colors have a similar hue, they should be separated by saturation (along the radius of the wheel) or by lightness (along the vertical axis). As a general rule, colors should be separated in at least one direction, but in no more than two directions.

2 Know your purpose.

Just because you like red doesn't mean that you have to use red in all your graphic designs. In some instances (say, a Sierra Club calendar) red might not be appropriate, and a color scheme should always reflect the purpose of your design as well as its intended audience. For example, in designing a book jacket, you have to consider the subject matter of the book, who will be buying it, and whether the colors will be sufficiently eye-catching on the shelf at the bookstore.

Ask yourself the following questions when you're ready to start choosing colors for your graphic design:

● What kind of effect do I want?

● What colors will best convey this effect?

● Are these colors clichéd and overused? What are the alternatives?

● Are these colors appropriate for my intended audience? Are they legible? Are they eye-catching?

● Can I improve the effect by changing any of the colors?

3 Choose the background color first.

If you were painting your apartment, the first color you'd choose would probably be a pale or pastel background color for the walls and ceiling; then you might pick a darker or more vivid shade for the molding and the trim. The same principle applies to graphic design: although your display type might be in a bold primary color, the overall effect of your design will depend much more on the subtlety of the background color (take a close look the next time you walk into a bookstore or print shop).

When choosing a background color, light colors work better than dark colors, warm colors look better than cool colors, and vivid colors are better than dull colors. In some designs, it's not always clear what's the background color and what's the accent color: as a general rule, choose the color for the largest area first, then the color for the next largest area, and so on until you've colored in all the details. Occasionally, you may have to choose an accent color first; for instance, if you're designing a poster for an avocado festival, you may want to use avocado green for the display type. In that case, simply pick a background shade that's harmonious with avocado green, but don't forget that the background color you pick will be at least as important as the accent color.

4 Choose the shades before the hues.

When choosing a color scheme, pick the shades first, not the hues. Although we tend to classify colors by their hue, like the colors of the rainbow, lightness is really much more important. In fact, all colors with the same shade (for instance, all light colors, or all dark colors) are pretty similar no matter what the hue, while colors with the same hue but different shades (for instance, sky blue, ultramarine, and navy blue) can be surprisingly different.

Choosing the shade first lets you decide on an overall effect: do you want a color that's vivid and showy, light and pastel, dark and subdued, or dull and gray? Start with the background color (which is often a light or dull shade), and then move on to your accent colors (which might be dark or vivid). *Then* find the hues that match your shades and best convey the effect that you want.

5 Vary the shades.

As we've said many times before, it's more important to vary the shades in a color scheme than to vary the hues. If you contrast light colors with dark colors, your color scheme will look bold and three-dimensional, but if you just contrast the hues, your color scheme may look flat and lifeless. How many books or posters (outside of Peter Maxx) use dark blue with dark brown, red with green, or pink with yellow? Even though these hues vary widely, they look disturbingly similar next to each other. But add black to red and green, or yellow to dark blue and dark brown (*see pages 134-135*), and suddenly the color scheme has depth.

6 Use compatible hues.

If you vary your shades as suggested above, it's important to find some common ground between your colors, and this usually means hues that are similar or otherwise compatible. As we've seen already, color combinations that vary both the shades and the hues almost always show *too much* contrast: there's a thin line between contrast and chaos.

To keep the color harmony at a reasonable level, use similar hues, or different shades of the same hue. You can even use contrasting or complementary hues as long as there isn't too much contrast in shade, but be careful when using colors that clash, like red and green or red and blue.

One way to make hues seem more compatible is to mix a little of the first hue with the second hue, and a little of the second hue with the first hue. For example, red-violet and blue-violet go much better together than red and blue.

7 Limit the number of colors.

Another way to increase color harmony is to limit the number of colors in your color scheme. Two or three colors is usually enough; five is too many. Four-color combinations must be selected with great care: nothing looks worse than too many colors, particularly when they lack common elements.

However many colors you use, make sure that there is only one dominant color: a color that sets the tone for the whole color scheme. The other colors should be clearly subordinate in either hue, lightness, or saturation.

8 Use vivid colors sparingly.

We can't emphasize too often that vivid colors must be used sparingly, or they will seem more annoying than striking (think of some of the day-glo billboards that you've seen recently). In general, use a vivid color as the accent color (for instance, in the display type), and a light or dull color for the background. If you need another accent color, use a darker shade of the vivid color.

Although vivid colors like red and blue are often used for the backgrounds of record albums and mass market paperbacks, the type is usually in black or white, since there is almost no way to mix two vivid colors without mediating them with a neutral or achromatic shade. You rarely see vivid colors used as the background in posters or packaging.

9 Use achromatic colors for harmony.

When in doubt, use an achromatic color: black, gray, or white. A common mistake when choosing a color scheme is to pick colors that are too strong or compete too much: they end up cancelling each other out. White or black, on the other hand, have a simplicity and elegance that attract our attention just as much as the boldest vivid colors. In addition, you won't have to worry about a clashing color scheme, since *everything* goes with black or white. The only thing you might have to worry about are all the other black and white book covers out there, or all the other gray posters, which tend to reduce the impact and originality of yours.

10 Use familiar colors.

Color schemes that use uncommon colors like magenta, cyan, or purple can sometimes look jarring and ugly even when they follow the rules of color harmony. Unless your intention is to shake up your audience, you will lose some points by using colors not often found in nature, or unfamiliar shades of familiar colors (for instance, dark yellow and orange, very pale blue and green). Obviously, this rule doesn't apply when your audience is very young, or very trendy: *Miami Vice* gets away with unfamiliar colors all the time. But for conventional audiences, use conventional colors.

11 Use natural colors.

The most familiar colors you can find are the colors in nature: trees, flowers, birds, insects, the sky, and the sea. Natural colors are harmonious by definition, since our eyes evolved for the very purpose of looking at them: there are no clashing hues in nature.

Our eyes are also very good at distinguishing between light and shadow, since we rarely see things that are evenly lighted in nature. (In fact, this is why it's more important to vary the shades in your color schemes than to vary the hues: the eye is much more sensitive to subtle gradations in brightness than to variations in the hue or wavelength of light.) Your natural color schemes should simulate this effect by using a wide range of shades, even shades of the same hue.

12 Be original.

To paraphrase George Orwell, ignore all of these guidelines rather than use a color scheme that's boring or ugly. Following all the rules of color harmony will not necessarily lead you to a beautiful color scheme, just as following all the rules of English grammar will not necessarily make a Hemingway out of you.

Originality might mean using a color combination that no one has ever used before, or a combination that seems to fly in the face of legibility and common sense. Or it might be a combination that is just subtly different from what we might expect, like an American flag that uses orange and violet instead of red and blue. But remember that a color scheme is truly original only if you're the first person to use it: our jaded color sense quickly adapts to any new trend in graphic design, and what was fresh and different a year ago might seem trite and overused today.

Color Conversion Chart

DIC	Yellow	Magenta	Cyan	Black	DIC	Yellow	Magenta	Cyan	Black
2	5	15			189		100	70	
5	15	25			197	80	100	30	
7	30	20			207	100	40	20	
12	50		25		208	100	20	20	
14	55		40		210	100	10	50	
15	40		50		215	70		100	
19	5		45		217	50	25	100	
20	5		50		292	50	70	40	
21		10	30		305	90	100	60	
23		30	15		317	80	70	40	
25		50			328	100	90	75	
27		70			354	100	70	70	
30	50	50			373	100	55	70	
32	50	15			375	100	50	80	
33	50				379	100	80	100	
51	50	80			381	60	10	60	
67			70		387	100	60	100	
82	90	70			411	60	80	100	
84	90	45			413	30	25	70	
96	30		90		429	20	30	60	
113		100			433	50	90	100	
126	100				436		45	60	
134	50		90		454		55	50	
144		75	80		465	45	80	80	
151		100	20		476	30	60	30	
156	100	100			497	50	90	65	
166	100	10			543				40
170	100		45		544				70
172	100		80		548				10
179			100		566				100
182		50	100						

Notes

Notes